HENRY MOORE
60 Years of His Art

WILLIAM S. LIEBERMAN
Chairman, Department of Twentieth Century Art

Thames and Hudson
and The Metropolitan Museum of Art

Copyright © 1983 by The Metropolitan Museum of Art
First published in the USA in 1983 by Thames and Hudson Inc.,
500 Fifth Avenue, New York, New York 10110
First published in Great Britain in 1983 by Thames and Hudson Ltd.,
30 Bloomsbury Street, London WC1B 3QP

Library of Congress Catalog Card Number 83-70580
ISBN 0-500-23376-4 (Thames and Hudson)
ISBN 0-87099-339-9 (Metropolitan Museum)

Designed by Janet Doyle
Printed in the United States of America

The Henry Moore exhibition at The Metropolitan Museum of Art has been made possible by a generous grant from Gould Inc. Foundation.

Table of Contents

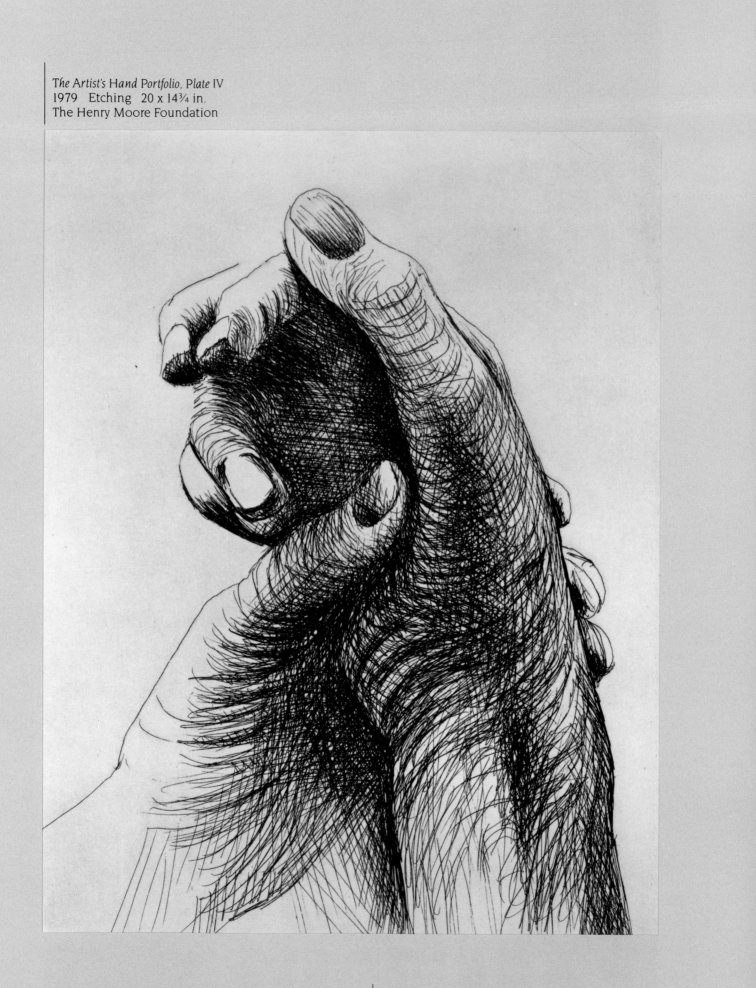

Foreword

Henry Moore has had a remarkable influence on our era, both as an artist whose monumental works have given us a new vision of humankind and as an individual whose continuing sense of discovery is an inspiration to creative people in all fields of endeavor.

Gould Inc. is an electronics company which has found the works of Henry Moore in its corporate art collection to be symbols of its commitment to innovation and exploration. The continuing interplay of forms and spaces which one experiences in a Henry Moore sculpture stimulates our imagination and encourages us to seek new approaches in our research laboratories and our training centers as well as in the management of our business.

We are privileged to sponsor "Henry Moore: 60 Years of His Art" at The Metropolitan Museum of Art, as a tribute to a great artist who has enriched our lives and as a contribution to those who will have an opportunity, through this exhibition, to see the full range of his work.

William T. Ylvisaker
Chairman of the Board and Chief Executive Officer
Gould Inc.

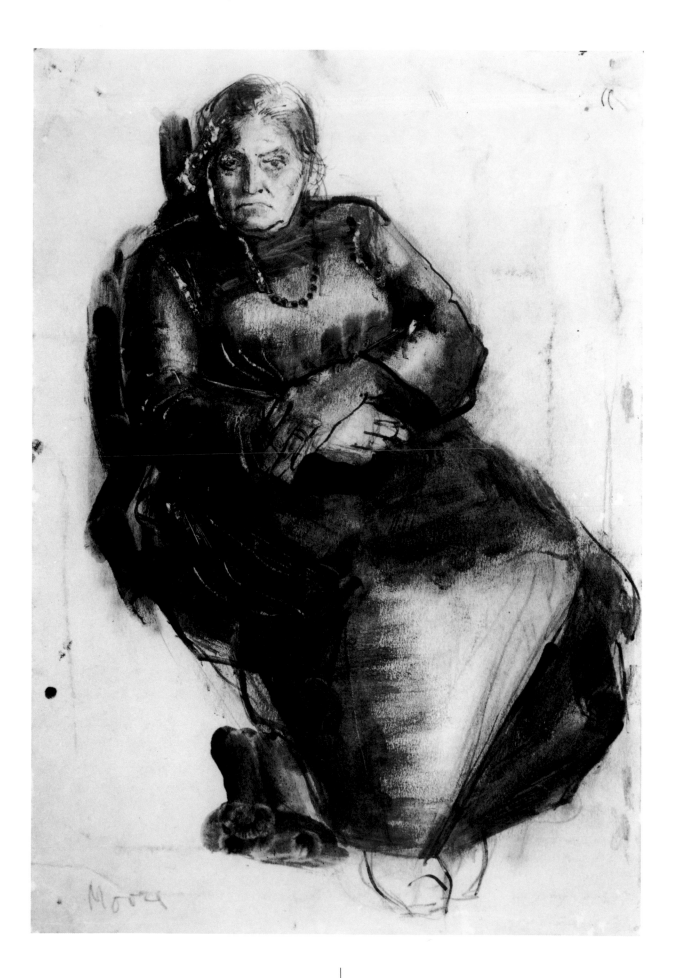

Acknowledgments

The collections of The Metropolitan Museum of Art embrace many cultures, and they encyclopedically illustrate artistic attainment. Within this frame of reference, it is a privilege to greet Henry Moore, a contemporary titan. He has significantly defined contemporary sculpture, and a large audience has been profoundly affected by his art. His protean creativity over six decades precludes a complete retrospective, and it has therefore been imperative to concentrate on pivotal stages in his artistic development. I wish to thank William S. Lieberman, chairman of our Department of Twentieth Century Art, for his keen assessment of Moore's oeuvre and his acute choice of works. His friendship with Moore as well as his admiration and advocacy of his achievement proved invaluable. Our exhibition pays particular attention to Moore's seminal years, specifically those carvings that indicate the creative intentions as well as the metamorphosis of ideas that reach ultimate, often monumental expression.

I would like to thank the several members of our Museum staff who have contributed to the organization of the exhibition and to its catalogue. In particular I wish to acknowledge Jeffrey Daly, our chief designer who, assisted by David Harvey as well as by Mr. Lieberman, supervised the installation of the exhibition. We are also grateful to the president and the directors of the Robert Lehman Foundation who have provided the galleries of the Robert Lehman Wing, magnificent spaces so dramatically suited to the display of the sculpture.

The Museum is indebted to the British Council, specifically to its director Julian Andrews and his supportive staff, for coordinating British loans. The British Council has also contributed to meeting the considerable cost of assembling these loans. Alan Bowness, director of the Tate Gallery as well as an authority on Moore's art, graciously persuaded the trustees of his museum to part with significant works for an extended period of time. For their contribution to the exhibition's catalogue I am grateful to Thames and Hudson in New York as well as London. Our foremost debt is to the trustees of the Henry Moore Foundation; their cooperation and substantive contribution have been essential.

Without the responsive financial support of Gould Inc. in Rolling Meadows, Illinois, the exhibition would not have been possible. It is difficult to thank adequately all the officers of Gould Inc., but I hope that will be the pleasurable duty of William T. Ylvisaker, its chairman and chief executive officer.

And to Henry Moore congratulations on your eighty-fifth birthday. I join the many lenders to this exhibition and your friends throughout the world who salute you on this happy occasion.

Philippe de Montebello

◁
The Artist's Mother
1927
Pencil and pen and ink with finger rub
and scraping 12¼ x 7 in.
The Henry Moore Foundation

Introduction

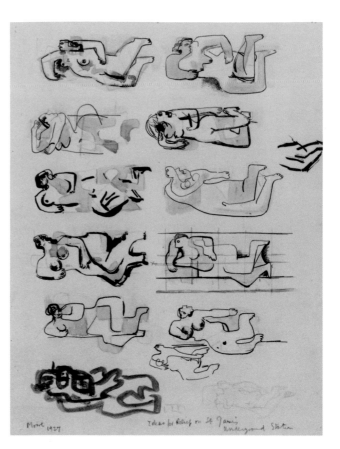

Ideas for the Relief "West Wind" 1927
Pen and brush and ink and watercolor 15 x 10 in.
Arts Council of Great Britain

For more than half a century, the art of Henry Moore has celebrated the dignity of man and the universal truths that underlie human experience. This retrospective, the first extensive study of his art in the United States since 1946, attempts to indicate the width of his vision and the wealth of his achievement.

The exhibition illustrates almost every aspect of Moore's art. The two media of his early sculpture in the 1920s and 1930s were stone and wood, and the survey starts with some fifty unique carvings from these years. These are followed by a series of small stringed sculptures from 1937 to 1940.

During World War II when perforce Moore could not sculpt, he concentrated upon drawing, most memorably scenes of people crowded in the Underground. After the war, he returned to carving, and these works became increasingly large in scale. Three commissions in stone—two versions of *Madonna and Child* and one reclining *Memorial Figure*—are permanently situated and therefore cannot be represented in the exhibition. In these carvings Moore deliberately adapted his style to suit a popular audience, and perhaps this is why

these three are the most classic, in a traditional sense, of any of his previous or later works.

The exhibition does include thirteen subsequent carvings in wood as well as stone, from 1945 to the present. The many castings in bronze progress from hand-size maquettes in plaster and larger working models cast in bronze to their final scale, the size of which was sometimes determined by a specific commission.

Although early as well as late drawings are represented, the exhibition concentrates on the two main themes of his wartime sketches: civilians taking refuge in London air-raid shelters and coal miners at work near his native Castleford. Finally, only the briefest selection suggests the variety of his printed oeuvre that begins after World War II. Consistent throughout is Moore's enormous ability to create works that combine poetic imagination and strength of form.

Curiously, Moore's extraordinarily innovative contributions as a sculptor are sometimes overlooked. This is perhaps because he has the very great capacity to communicate directly and without confusion. The spectator responds easily to the clear expression of his metaphors. In the twentieth century, such visual empathy is rare. That ability to transmit emotional impact, however, is the substantive greatness of his art. In either figurative or abstract idioms—he does not differentiate between them—Moore has produced much of the most significant sculpture of our time.

In 1929 Henry Moore completed his first commission for a public place, a relief eight feet long and at that time the largest of his carvings. Prophetically, it was also a figure created to be seen out-of-doors. The commission was for the decoration of the headquarters of the Underground Railway, a new building in Westminster and one of the tallest structures in London. Moore was just thirty, and although he needed and wanted recognition, he had been hesitant about accepting this commission because it specifically called for a relief. Since a relief is never freestanding, it cannot of course be seen in three dimensions; and throughout his career Moore has been reluctant to create sculpture that serves only as surface embellishment to architecture. Fortunately, the subject of the commission was congenial. In the summer of 1927, he had completed his first distinctive recumbent figure and the Underground Building commission was for a horizontal, albeit "flying," nude. The theme of the recumbent female figure became one of the most constant in his art. He would explore it in a variety of poses and in varying sizes.

Moore was not the only artist commissioned to ornament the face of the Underground Building.

In all, six sculptors had been invited to carve eight reliefs, symbolizing twice each the Four Winds. Although the subject may seem incongruous as a celebration of a subway system, the eight representations were intended to personify fleetness of movement in the air. Eric Gill, the best known of the six sculptors, appropriated three of the Four Winds—the North, South, and East—and in addition he coordinated the work of the other five sculptors. Moore, considerably younger than Gill, was invited to carve one of the two personifications of the West Wind. All eight reliefs span facades on the seventh story of the Underground Building, and all were designed to be seen upward from street level. Each was carved in the same Portland stone that cases the building, and in each the single figure is massive and heavy-limbed. Only Moore's relief makes no attempt to refer explicitly to flight or wind. His figure is the most simplified, and today it seems the most successful and certainly the least dated. Unlike those who shared the commission, Moore shied clear of Art Deco.

The actual carving of *West Wind*, up to then Moore's most ambitious effort, was not without difficulty. In the autumn of 1928 he received in his small London studio the three large vertical blocks that were to be joined together to form the eight-foot horizontal relief. Moore roughed out the composition, but the massive stones so crowded his studio that he could not take perspective on what he was carving. Therefore the blocks were removed to the building and joined together on its facade. Moore finished the carving in situ, an acrobatic, indeed an athletic feat. Carving, as he has frequently pointed out, is not painting—cutting stone demands physical prowess. As Moore says, a man must be strong and tough to undertake the profession of a sculptor.

It was Jacob Epstein, the Anglo-American sculptor almost twenty years Moore's senior, who had suggested him for one of the commissions. In 1928, at Moore's first one-man exhibition, Epstein had purchased for himself a small carving in alabaster, a baby feeding from a breast, perhaps of 1927 and apparently now lost. Epstein's own contributions to the face of the Underground Building were more prominent than any of the Four Winds. His two huge figures, *Day* and *Night*, sit upright and rigid. *Day* protects his child, a boy; *Night* laments hers who, disturbingly, can be only Christ. Both of Epstein's carvings were situated directly above the main entrances of the building.

Later, in 1931, Epstein contributed a brief preface to the catalogue of Moore's second one-man exhibition. With praise that reveals his own prejudice he wrote: "What is so clearly expressed is a

vision rich in sculptural invention, avoiding the banalities of abstraction and concentrating upon those enduring elements that constitute great sculpture...sculpture in England is without imagination or direction. Here in Henry Moore's work are both qualities." Moore would, of course, relate abstraction to the human form more successfully than any other twentieth-century artist.

West Wind was completed in the spring of 1929. Moore was married in July. He had had a happy childhood, secure and with a strong sense of family; he had already begun a dedicated career as a sculptor, and with marriage he gained a supportive companion who knew that she would be obliged to sacrifice her own career as an artist to nourish his.

Moore cannot remember when he first started to whittle with a penknife, but he does recall his first deliberate carving, a commission that he received as a schoolboy. Alice Gostick, his art teacher at the Castleford Secondary School, perceived his talent and, more important, was sympathetic to it. The headmaster had decided that a Roll of Honor should commemorate by name those former students who had joined the armed forces in World War I. Several had died and the war was still being fought. A plaque honoring their patriotism seemed appropriate, at least to the headmaster. Miss Gostick made certain that her student received the commission. She also supplied an oak panel as well as the necessary tools. The year was 1916, and young Moore had already decided to become a sculptor.

In the summer of 1921, after his own traumatic experiences in the war and his subsequent apprenticeship at Leeds College of Art, Moore arrived in London. He had won a substantial scholarship to study sculpture at the Royal College of Art. None of his modeled exercises in plaster and clay of that time survive. They seem to have been fairly academic, and a Head of the Virgin in marble (1922–23) after an Italian Renaissance relief shows how realistically he could delineate human features. Moore, however, found Renaissance sculpture too close to painting, and several carved pieces of the early 1920s reveal that his most profitable instruction was not received at the Royal College but from his study of primitive and archaic sculpture in the British Museum. Some of the examples of Egyptian and Greek art that he admired existed only as fragments, and this is reflected in his own carvings.

From 1923 until a six-month period of travel in Italy and France in 1925, several works mark Moore's progress toward a personal style. In retrospect, the most significant of these early carvings seem to be: a half-figure in verde di prato of 1923; a standing woman and a headless seated woman, both of 1924; and the exultant half-figure Woman with Raised Arms completed before his European trip. During the same period, his first explorations of the theme of mother and child began with a seated figure of 1922 and a squat Maternity of 1924 that lead to the heroic half-figure Mother and Child begun in 1924 and completed soon after his return to England. Acquired by the City Art Gallery of Manchester, this Mother and Child in Hornton stone is perhaps the most successful of Moore's early carvings. Hieratic in pose, compact and solid in form, it measures almost two feet high. Mother and child are locked together as a single figure.

Moore resumed work after his return to England, and a personal crisis developed in his art. His studies in Italy and his realization of the sophisticated accomplishment of Hellenistic and Renaissance sculpture conflicted with his admiration for the more intuitive and direct examples that he so admired in the ethnographic installations at the British Museum, which had already been the major influence on his art.

Nevertheless, in a Western tradition, Moore modeled in clay a headless and armless Torso (1925–26), five feet tall, at that time his largest sculpture, and in terra-cotta two smaller figures, a half-figure Woman Combing Her Hair (1927) and a full-figure Seated Woman (1928). Subsequently Moore destroyed all three. He had decided to remain a carver of dry stone and not a modeler in wet clay or plaster. Moore also destroyed two large carvings, both standing female figures of 1926. The first looked back to 1924; the other, decoratively stylized in pose and gesture, may have seemed too closely derived from Gaudier-Brzeska, Epstein, and Gill.

During the late 1920s when Moore resumed regular visits to the British Museum, he concentrated less upon looking at African carvings in wood. Other contemporary artists, he realized, had already derived inspiration from similar works. He would continue to emulate the integrity of African sculpture to volume, to the specific trunk of a tree, but he also looked elsewhere. What excited his imagination most were Toltec and Aztec carvings in stone, and these he studied in original examples as well as in books. The famous Chac-Mool Figure, today the single most popular exhibit in Mexico City's Anthropological Museum, created a lasting impression. Indeed it served as a catalyst as well as a confirmation of his own direction as a sculptor. Several masks in stone and concrete suggest this resolution, and it is amplified by the Reclining Figure (1929) in the collection of the Leeds City Art Galleries and the Reclining Woman (1930) in the National Gallery of Canada, both carved in Hornton stone.

During the 1930s the focus of Moore's sculp-

ture became increasingly three-dimensional, and space carved out of form became the most familiar characteristic of his art. By piercing wood and soon after stone, he created holes within the body of his shapes. As these orifices grew larger, the voids created became integral to his articulation of form, and these spaces led to opened-out figures that culminate in the *Recumbent Figure* in stone of 1938, first publicly shown during New York's World's Fair a year later and today in the collection of the Tate Gallery in London.

During the 1930s Moore also produced his most abstract carvings. These include not only rectangular shapes but also compositions that juxtapose multiple elements. In 1937 he began a series of sculptures in metal and wood that further explore space and that exploit string to connect forms. The decade ended with two unexpected images: the tense *Three Points*, a small sculpture originally cast in iron, and the ominous *Helmet*, originally cast in lead. The latter anticipates his later development of interior and related forms. In both there is a premonition of castastrophe.

From his first drawings from the model to his most recent studies of the roots of trees, draftsmanship has been a rich ingredient in Moore's art. It was essential to the conception of his early carvings, and many of the pieces are themselves incised with lines. His wartime shelter and coal-miner scenes, however, develop themes independent of his sculpture.

After the mid-1940s Moore relied more frequently on small maquettes modeled in clay and cast in plaster rather than on drawing to develop sculptural ideas. Once modeled, these maquettes were enlarged, and they were examined and reworked before they were cast in bronze or cut in stone. His ideas were thus conceived in three dimensions so that preliminary studies on paper became less necessary. Indeed, most of his late drawings do not specifically relate to his sculpture.

After World War II Moore's approach to sculpture remained that of a carver, despite the primacy of bronze casting in his later work. He continued to need direct contact with a resistant block of stone or the textured grain of a trunk of wood. Bronze, however, allowed him a greater freedom of form. It was also more suited to the numerous commissions that he undertook for public places. In their final size, these commissions stand as monuments, and they are best seen out-of-doors in the locations throughout the world where they have been permanently installed. Moore personally prefers to see his sculpture in landscape and not in front of buildings where their appearance seems occasionally perfunctory and sometimes obligatory.

As his fame increased, Moore found that he became an official ambassador of British culture. He accepted this role graciously but not without misgiving, and he would find it almost impossible to maintain a private life. As an artist, he was internationally recognized. In urban locations throughout the world it seemed mandatory to erect one sculpture by Henry Moore, to celebrate a city, to identify a museum, to lend distinction to an office building or to architectural complexes concerned with finance, industry, or the arts. Commissions crowded in for him; none of these, however, he actively sought. The danger that Moore would become a cultural commodity was fortunately completely dispelled by the retrospective exhibition of his sculpture and drawings in and around the Forte di Belvedere, Florence, in 1972. No exhibition of his achievement can ever be more eloquent.

To understand his art completely, one must realize that Moore is incapable of not thinking in three dimensions and that in the smallest handful of clay he can see a figure as tall as a giant. Photographs of his sculpture are often misleading. A carving the length of a pencil appears many times larger when photographed against the sky, his favorite background. He himself is the most accurate and the least interpretive photographer of his own work, and certainly it was his own early photography that first suggested to him the possibilities of sculpture on a monumental scale. "Most everything I do," he recently said, "I intend to make on a large scale if I am given the chance. So when required to make a work larger, I am always pleased. Size itself has its own impact, and physically we can relate ourselves more strongly to a big sculpture than to a small one. At least I do."

Recumbent and seated women, usually nude but sometimes draped, family groups focusing on mother and child, internal shapes articulated within their exteriors, and totemic motifs are hallmarks of Moore's art. During the 1960s and 1970s, however, thematic constancy did not preclude stylistic change, and in most of his recent sculpture there is no primary frontal view. Single heraldic images stand mysteriously and dramatically by themselves; multiple and related forms create their own environment.

Many of his latest works depart from representational imagery and return to interpretive abstraction. These abstractions, several of which derive from the human figure, sometimes incorporate organic forms as well as an increasing experience of landscape itself. However, his most recent sculpture included in the exhibition, the *Reclining Mother and Child* of 1982, resumes his earliest and most enduring theme.

Chronology

1898 Born July 30 at Castleford, Yorkshire, a coal-mining town near Leeds. Seventh child of Raymond Spencer Moore (1849–1922) and Mary Baker Moore (1857–1944).

1902–10 Attends Castleford primary school and wins scholarship to the local grammar school.

1915–16 Gains his Cambridge senior certificate and begins studying to be a teacher. Although determined to be a sculptor, returns to work at his old school in Castleford.

1917 To enlist in Civil Service Rifles battalion, first trip to London. Spring: first visits British Museum and National Gallery. Summer: sent to France. November: gassed in the battle of Cambrai. December: hospitalized in England.

1918 Convalesces. Autumn: reenlists and is sent to France.

1919 February: demobilized. Resumes teaching post in Castleford. September: at the age of twenty-one begins two years of study at Leeds College of Art.

1920 First contacts with modern painting (Cézanne, Gauguin, Kandinsky, Matisse, Rouault) and African sculpture in collection of Sir Michael Sadler, vice-chancellor of Leeds University.

1921 Wins Royal Exhibition Scholarship to study sculpture at Royal College of Art, London. Models in plaster. Visits British Museum frequently and studies Egyptian, Etruscan, Mexican, Oceanic, and African sculpture.

1922 Vacations in Norfolk, where he sculpts out-of-doors. First direct carvings in stone and in wood, influenced by primitive and archaic sculpture.

1923 Stone carvings of heads and figures. First of several visits to Paris that continue until 1939. In Paris sees paintings by Cézanne in Auguste Pellerin collection.

1924 Wins traveling scholarship from Royal College of Art, London, but postpones European trip for one year to accept appointment at the college as sculpture instructor. Spring: exhibits for the first time in a group show at the Redfern Gallery, London. Begins first reclining figure in stone (since destroyed).

1925 Completes *Mother and Child* (City Art Gallery, Manchester). Late January through mid-July: on Royal College of Art scholarship travels in France and Italy.

1926 Experiments with cast-concrete sculpture.

1927 Initiates a series of masks which continues through 1930. Summer: first *Reclining Woman* in cast concrete (private collection).

1928 Thirtieth birthday. First solo exhibition, Warren Gallery, London. First public commission, *West Wind*, a carved relief in stone for one facade of new headquarters of the Underground Railway, a building in Westminster, London.

1929 Spring: completes *West Wind* commission. July: marries Irina Radetzky, a painting student at Royal College of Art. Stone carvings and first *Reclining Figure* (Leeds City Art Galleries) influenced by Aztec sculpture.

1930–31 Elected to "7 and 5 Society" (1920–35), London, a group of avant-garde artists, whose members include Barbara Hepworth, Ivon Hitchens, Ben Nicholson, and John Piper. Stone carvings continue to reflect Mexican influence. First appearance of pierced holes in sculpture.

1931 First of four solo exhibitions at Leicester Galleries, London. Begins biomorphic abstract compositions. Acquires cottage at Barfreston, a village in Kent, for summer vacations.

1932 Leaves Royal College of Art to assume directorship of new department of sculpture at Chelsea School of Art, London, a position which he holds until 1940.

1933 Develops and amplifies use of holes as space in wood and stone. Invited to join "Unit 1," an avant-garde group founded by Paul Nash, whose members include painters and sculptors Edward Burra, Barbara Hepworth, Ben Nicholson, and Edward Wadsworth and architects Wells Coates and Colin Lucas; as a group, they exhibit during June the next year.

1934 Moves to cottage at Kingston, near Canterbury in Kent, which has a large field enabling outdoor work. First monolithic, rectilinear abstract forms. First compositions in two or more pieces. Publication of first monograph devoted to his art— *Henry Moore: Sculptor*, by Herbert Read.

1935 Abstract carvings in stone and wood. Begins carving in wood first open *Reclining Figure* (Albright-Knox Art Gallery, Buffalo), completed 1936. Uses

maquettes (small models) in addition to drawings as preliminary studies for carvings.

1936 Signs artists' and poets' manifesto against British policy of nonintervention in Spanish Civil War. Only trip to Spain; sees cave paintings in the Pyrenees and at Altamira; visits Barcelona, Madrid, Toledo. Represented in "International Surrealist Exhibition" at New Burlington Galleries, London. *Two Forms*, 1934, in wood, included in Alfred H. Barr Jr.'s exhibition "Cubism and Abstract Art" at The Museum of Modern Art, New York. Later that year *Two Forms* and *Reclining Figure*, 1931, in lead, included in Barr's exhibition "Fantastic Art, Dada, Surrealism."

1937 Joins British Surrealist group. As gift of Sir Michael Sadler, *Two Forms* acquired by The Museum of Modern Art, first work to enter the collection of an American museum. Begins stringed figures in wood; others during next two years are also in lead and bronze.

1938 Fortieth birthday. Summer: large stone sculpture *Recumbent Figure* (Tate Gallery).

1939 Stops teaching at Chelsea School of Art to devote himself entirely to sculpture. *Recumbent Figure* (Tate Gallery) first exhibited at New York World's Fair, subsequently shown in The Museum of Modern Art's garden until 1945. First internal/external sculpture, a helmet in lead. September: World War II begins.

1940 Works on small sculptures in lead, but concentrates on drawing. After spring, stops sculpture completely. September: drawings of people in London Underground shelters during the Blitz. Visits shelters at night, then returns to studio to record observations in drawings from memory. Appointed official War Artist (until 1942) October: London studio damaged by bombing. Takes house at Perry Green, Much Hadham, Hertfordshire, where he still lives.

1941 First retrospective, Temple Newsam, Leeds. First appointment as trustee of the Tate Gallery. Continues shelter drawings.

1942 January: under auspices of the War Artists' Advisory Committee, returns to Castleford to observe and draw miners at work. Later in the year resumes drawings for sculpture.

1943 First foreign one-man exhibition, Curt Valentin's Buchholz Gallery, New York. Resumes sculpture. Begins multiple casts in bronze of works realized in plaster. These maquettes serve as models for larger bronzes. Receives commission to carve *Madonna and Child* in stone for Church of St. Matthew, Northampton, completed February 1944.

1944 First volume of catalogue raisonné, *Henry Moore: Sculpture and Drawings*, published by Percy Lund, Humphries and Company, London.

1945 Honorary doctorate from University of Leeds, the first of many academic awards. First appointment as member of the Art Panel of Arts Council. November: first postwar visit to Paris.

1946 Birth of daughter, Mary. First foreign retrospective, The Museum of Modern Art, New York; also shown the following year at The Art Institute of Chicago and The San Francisco Museum of Art. On the occasion of the exhibition in New York, first trip to the United States. October: completes *Memorial Figure* in stone for Dartington Hall, Devon.

1947 August: begins large *Three Standing Figures* in stone; completed and installed next year in Battersea Park, London, gift of the Contemporary Art Society.

1948 Fiftieth birthday. Appointed committee member of first London County Council Open-Air Exhibition of Sculpture (Battersea Park). In Venice receives International Prize for Sculpture at 24th Biennale, first of several international awards. First life-size bronze *Family Group*, completed 1949, commissioned by Barclay School of Art, Stevenage. Begins carving *Madonna and Child* in stone, commissioned for St. Peter's Church, Claydon, Suffolk, completed 1949.

1949 Reappointed trustee of Tate Gallery. Visits Belgium, the Netherlands, and Switzerland.

1950 Works on Arts Council of Great Britain commission for large bronze *Reclining Figure* for 1951 Festival of Britain.

1951 Begins abstract sculpture with internal/external forms. First trip to Greece. First London retrospective, Tate Gallery.

1952 Begins work on commission for stone *Screen*, completed 1953, and bronze *Draped Reclining Figure*, both for new Time-Life Building, London. Begins large bronze *King and Queen*, completed 1953.

1953 Wins International Prize for Sculpture at Second São Paulo Bienal, Brazil. Only trips to Mexico and Brazil. Begins large wood version of upright internal/external sculpture; also large bronze internal/external reclining figure.

1954 Visits Italy, Germany, and the Netherlands. Completes large bronze *Warrior with Shield*; works on carved *Family Group* in stone for Harlow New Town, Hertfordshire. Begins work on commission for brick wall-relief at the Bouwcentrum, Rotterdam.

1955 Appointed trustee of National Gallery, London. Begins series of freestanding totemic sculptures with interrelated biomorphic forms. Begins final large-scale *Upright Motive No. 1: Glenkiln Cross*, in bronze, completed 1956. Elected foreign honorary member of the American Academy of Arts and Sciences.

1956 Receives commission for new UNESCO headquarters, Paris. Begins sculptures cast in bronze that provide their own architectural setting.

1957 Completes bronze *Falling Warrior*. In Italy carves UNESCO *Reclining Figure* in marble at the stoneyard at Querceta, near Carrara, completed 1958. Awarded prize at the Carnegie International, Pittsburgh.

1958 Sixtieth birthday. On the occasion of honorary doctorate from Harvard University, visits Boston and San Francisco. October: UNESCO *Reclining Figure* installed. Large bronzes of draped women.

1959 Small bronzes of animals and birds. First two-piece bronze reclining figure.

1960 Landscape metaphor increasingly pronounced in figurative sculptures.

1961 First exhibition at Marlborough Fine Art, London. First large knife-edge sculptures. Elected member of the American Academy and Institute of Arts and Letters.

1962 Begins work on bronze *Locking Piece*. Commissioned to create first oversized outdoor sculpture for reflecting pool at Lincoln Center for the Performing Arts, New York.

1963 Completes bronze *Large Torso: Arch*. Begins two-piece *Reclining Figure* in bronze for Lincoln Center and collaborates with American architect Gordon Bunshaft on project.

1964 Continues work on Lincoln Center commission. Completes final large-scale version of bronze *Locking Piece*. Begins work on commission for large bronze abstraction, *Nuclear Energy: Atom Piece* (unique cast), for the University of Chicago, completed 1966. Awarded Fine Arts Medal by the American Institute of Architects.

1965 Completes large bronze *Knife-Edge: Two-Piece*. Acquires cottage at Forte dei Marmi, Italy, near Carrara quarries, as annual summer studio for carving in stone. Starts work on commission for bronze *Sundial* (unique cast) for The Times Building, London, completed 1966. Completes Lincoln Center two-piece *Reclining Figure* (unique cast), gift of Vera and Albert List. September: visits New York for dedication.

1966 Honorary doctorate from Yale University. Visits New York and Canada. Final large-scale version of bronze *Three Way Piece, no. 2: Archer*, 1964–65, placed before City Hall, Toronto.

1967 Announces intention to donate major works to the Tate Gallery. Honorary doctorate from University of Toronto. Also visits New York, Philadelphia, and Chicago. Unveils final large-scale version of *Nuclear Energy*, 1964–66, bronze (unique cast), at University of Chicago, and *Three Way Piece no. 1: Points*, 1964–65, bronze, at Columbia University, New York. Creates *Double Oval* bronze, for Chase Manhattan Bank, New York, first major piece intended to be walked through.

1968 Exhibitions at Tate Gallery and elsewhere in Europe mark his seventieth birthday. Awarded the Einstein Prize by Yeshiva University, New York.

1969 Begins etchings based on elephant skull. *The Arch*,1963–69, bronze, installed outside Bartholomew County Public Library, Columbus, Indiana, designed by American architect I. M. Pei.

1970 Visits United States for installation and opening of dual exhibitions at Marlborough and Knoedler galleries in New York. Publication of series of etchings, *Elephant Skull Album*, 1969–70.

1971 Final large-scale version of *Oval with Points*, 1968–70, bronze, installed at Princeton University. Visits Toronto to plan Henry Moore Sculpture Centre at Art Gallery of Ontario.

1972 Major retrospective exhibition in and around the Forte di Belvedere, Florence.

1973 First volume of Gérald Cramer's *Henry Moore: Catalogue of Graphic Work* published.

1974 Henry Moore Sculpture Centre opens at Art Gallery of Ontario, Toronto; collection includes large gift by the artist of 101 sculptures featuring many plasters, 57 drawings, and almost complete set of prints. Honorary doctorate from Columbia University, New York. Publication of series of lithographs, *Stonehenge*, 1972–73.

1975 Publication of series of etchings, *Sheep Album*, 1972 and 1974.

1977 Establishment of the Henry Moore Foundation in Much Hadham, Hertfordshire.

1978 Gift of thirty-six sculptures to Tate Gallery featured by exhibition celebrating eightieth birthday. *Mirror: Knife-Edge*, 1977, bronze (unique cast), installed outside National Gallery of Art, Washington, D.C. *Large Two Forms*, 1966–69, bronze, installed at Gould Center, Rolling Meadows, Illinois. Completes largest wood *Reclining Figure* (Henry Moore Foundation).

1979 Series of etchings of trees.

1980 Gives final large-scale version in marble of *Large Arch: Torso* to England's Department of the Environment for permanent installation in Kensington Gardens, London.

1981 Major retrospective exhibition in and around Palacio de Velásquez, Madrid; a version of exhibition travels to Fundação Calouste Gulbenkian, Lisbon, and Miró Foundation, Barcelona.

1982 Henry Moore Centre for the Study of Sculpture opens at the Leeds City Art Galleries. Retrospective exhibition at Museo de Arte Moderno, Mexico City.

1983 Exhibition, "Henry Moore: 60 Years of His Art," opens at The Metropolitan Museum of Art, New York.

Early Carvings

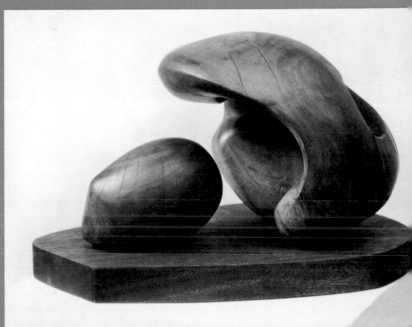

Two Forms
1934
Pynkado wood
L. 17¾ in.
The Museum of Modern Art, New York,
Purchase, Sir Michael Sadler Fund

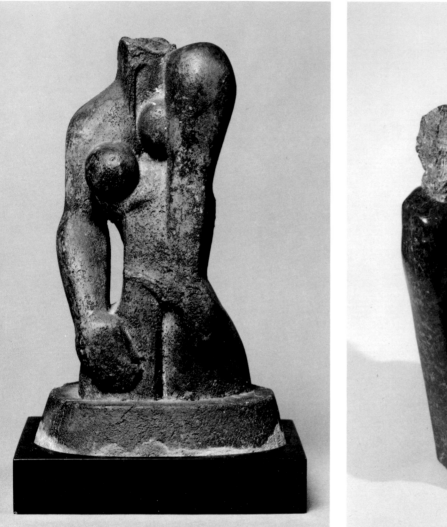

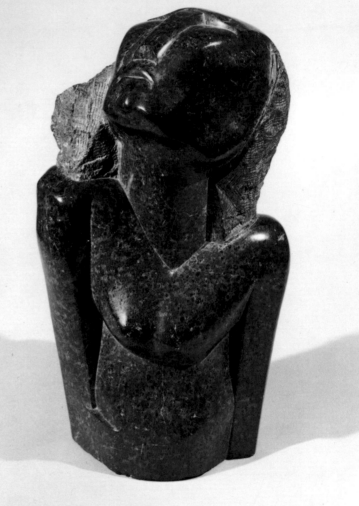

Torso
1926
Cast concrete
H. 8½ in.
Mrs. Allan D. Emil, New York

Figure
1923
Verde di prato
H. 15½ in.
Private Collection

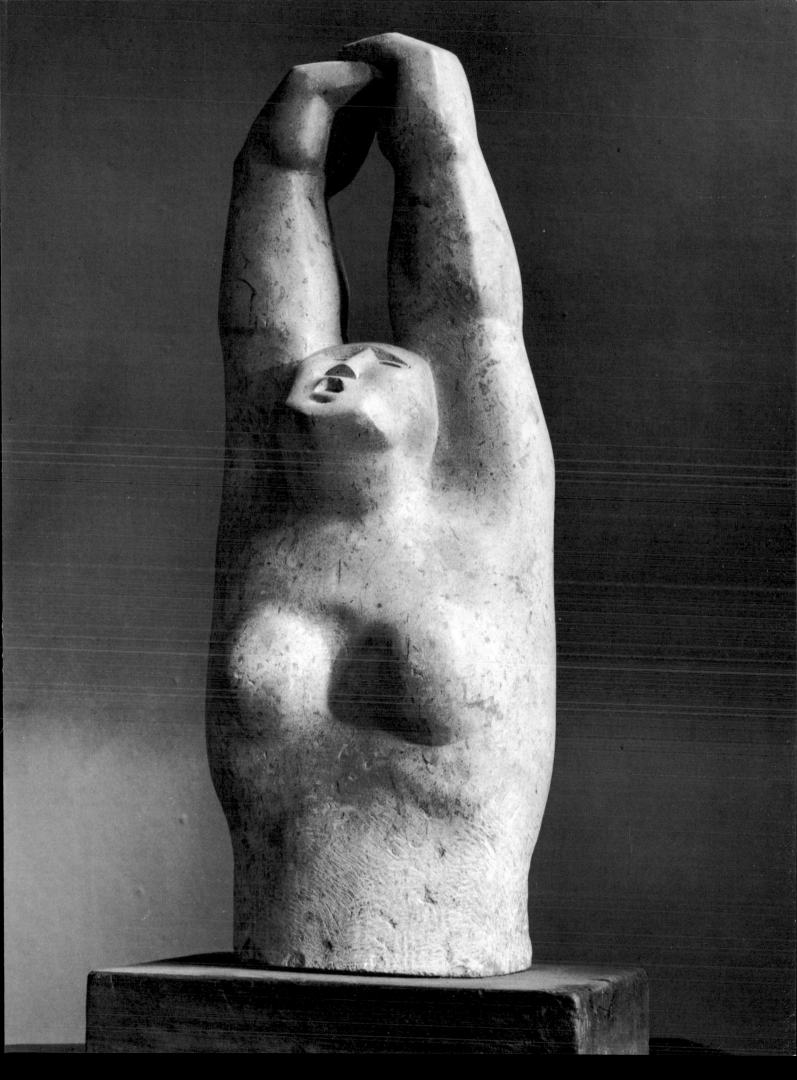

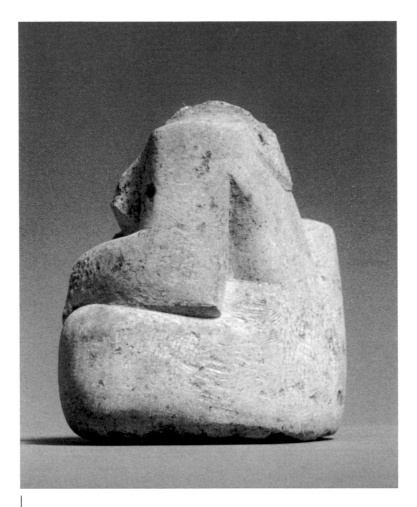

Seated Figure 1924 Hopton-wood stone H. 10 in.
The Henry Moore Foundation

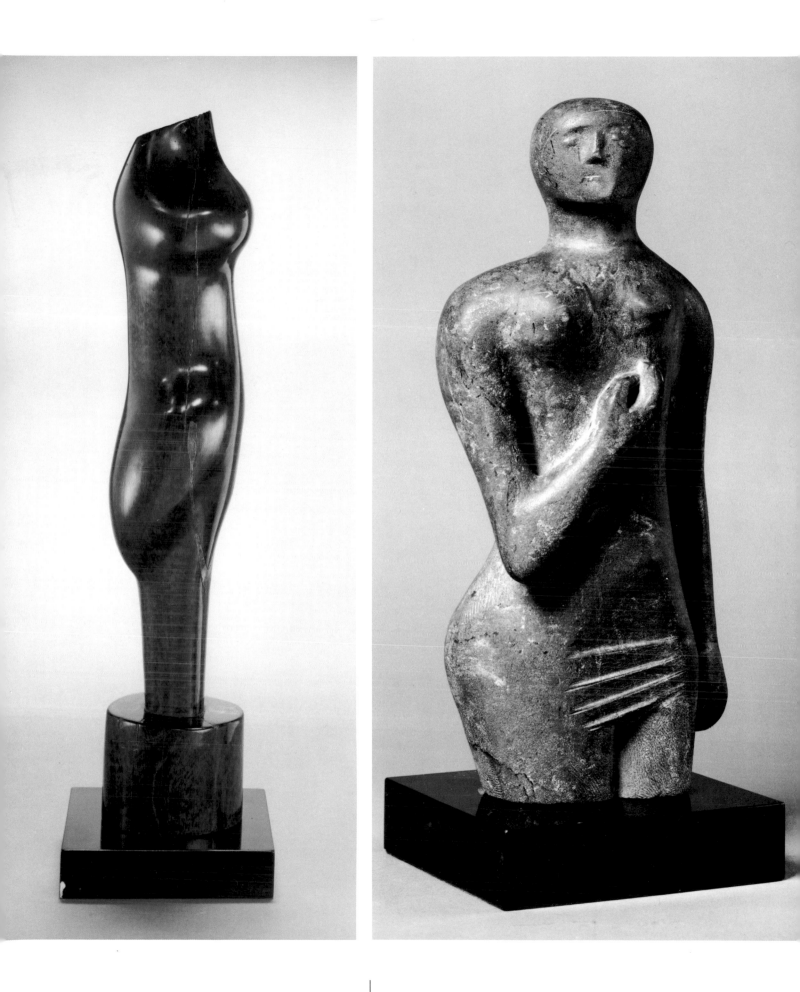

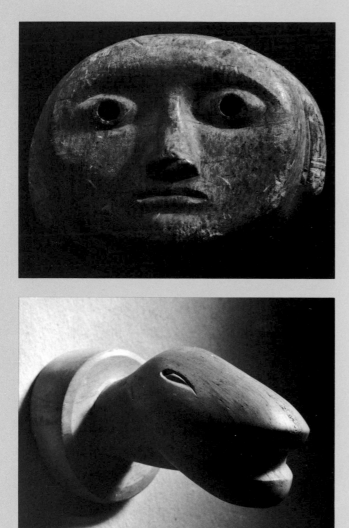

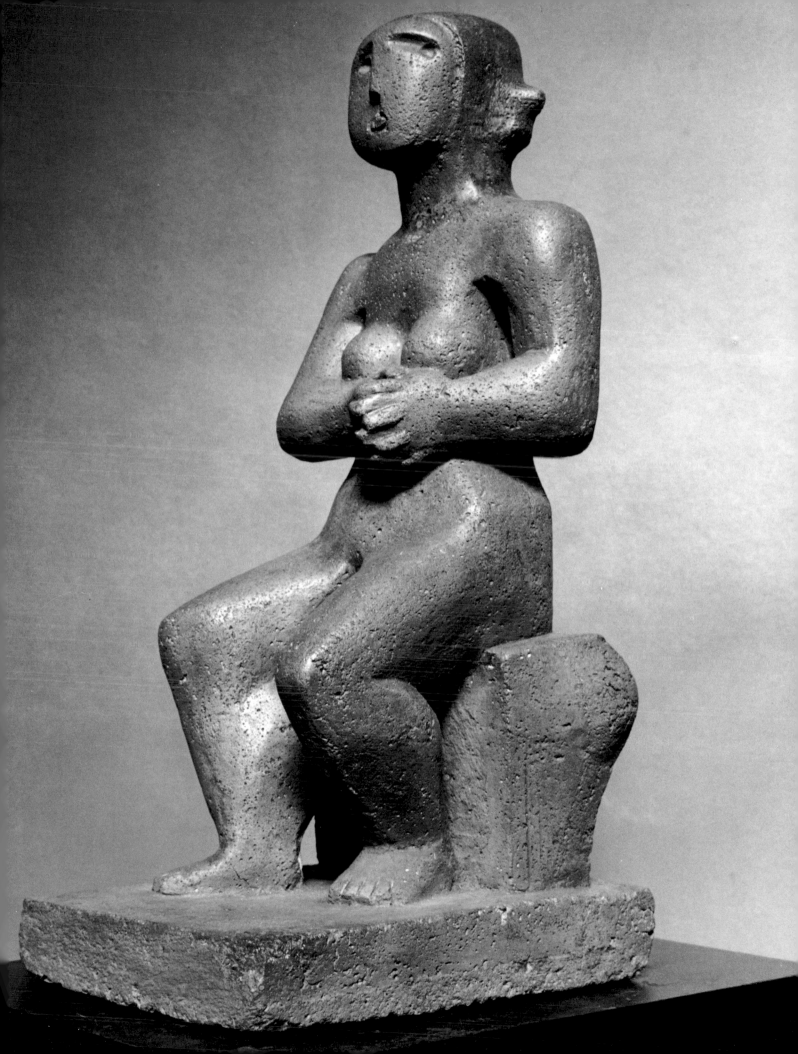

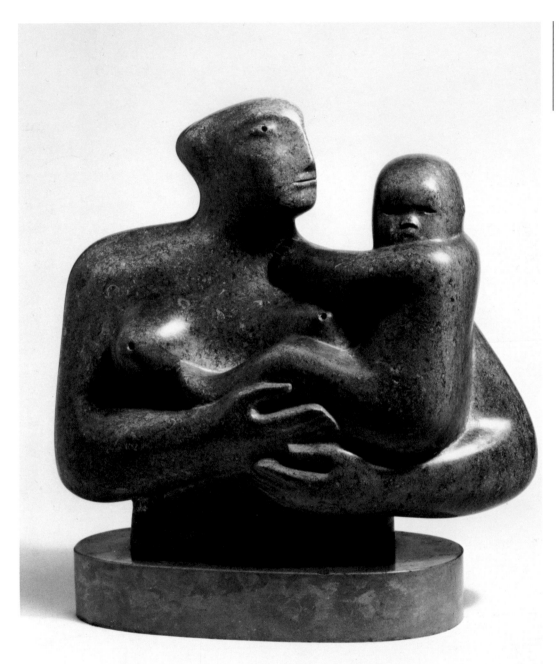

▷
Mother and Child
1930
Ancaster stone
H. 10 in.
Private Collection

▷
Seated Figure
1930
Alabaster
H. 18¼ in.
Art Gallery of Ontario,
Toronto, Purchase

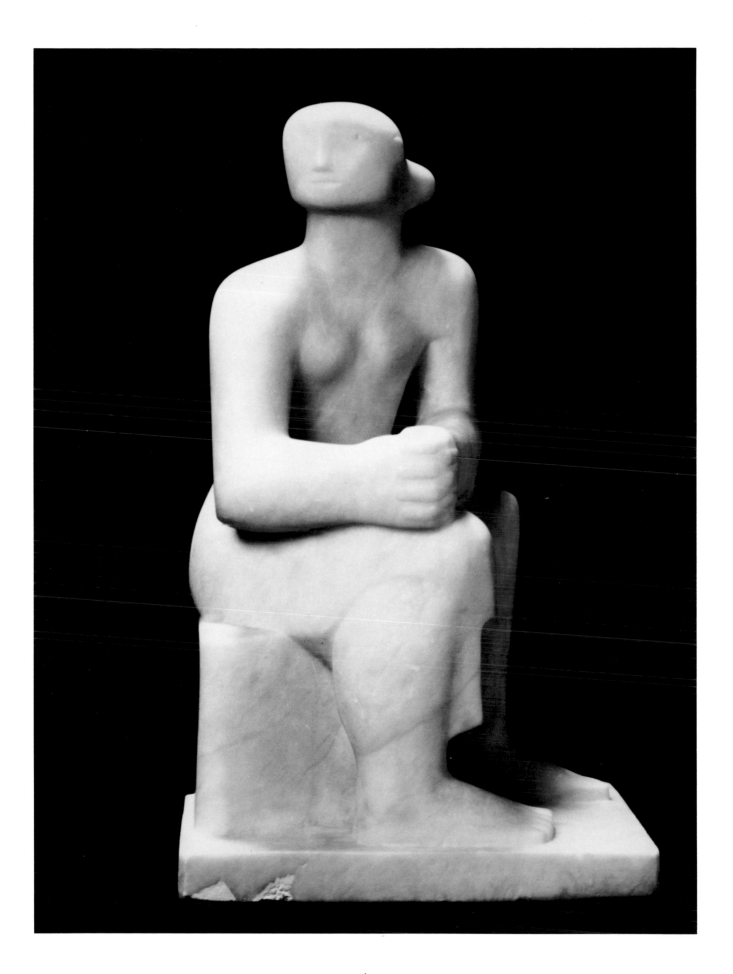

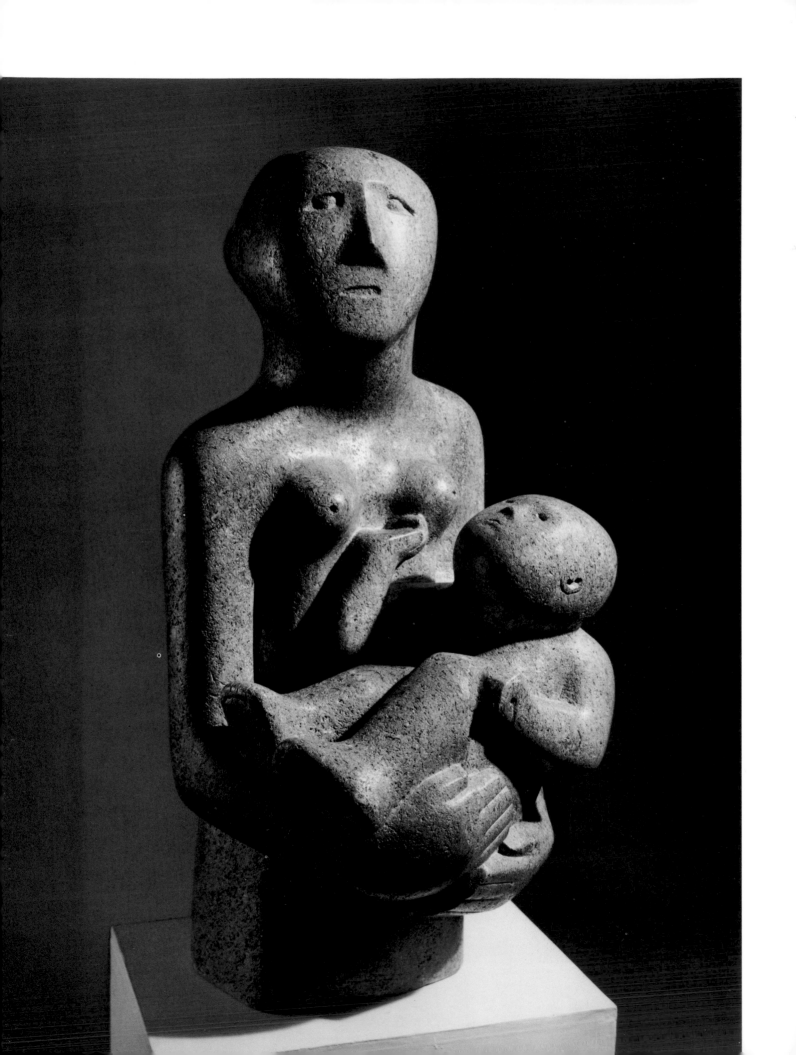

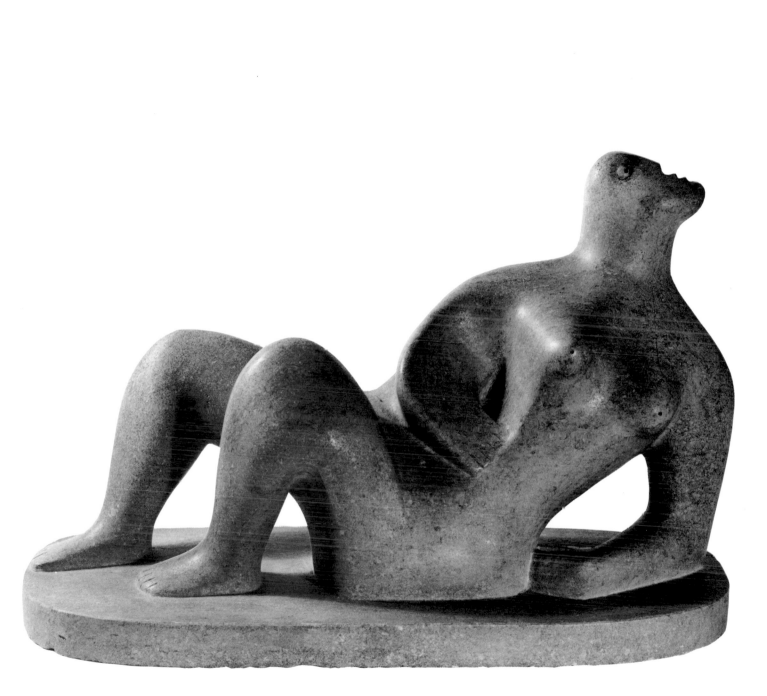

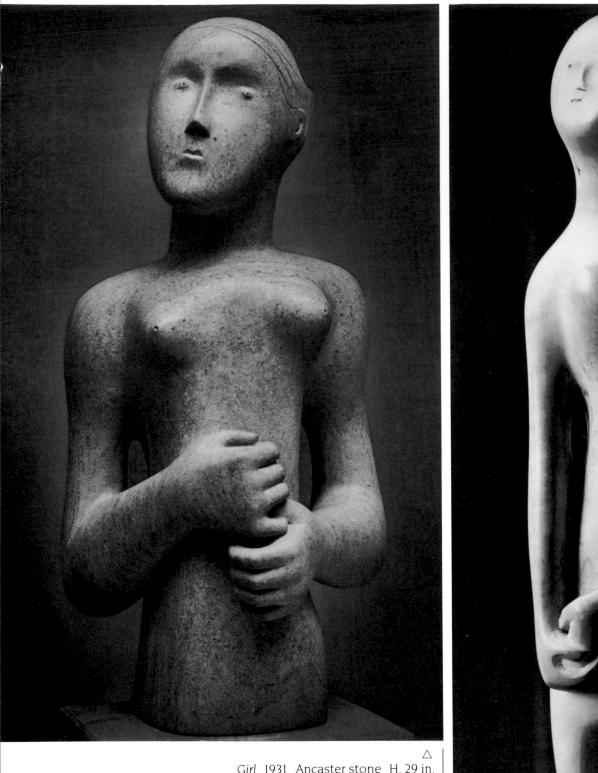

Girl 1931 Ancaster stone H. 29 in.
Tate Gallery, London, Purchase

Girl 1932 Boxwood H. 12½ in.
Private Collection

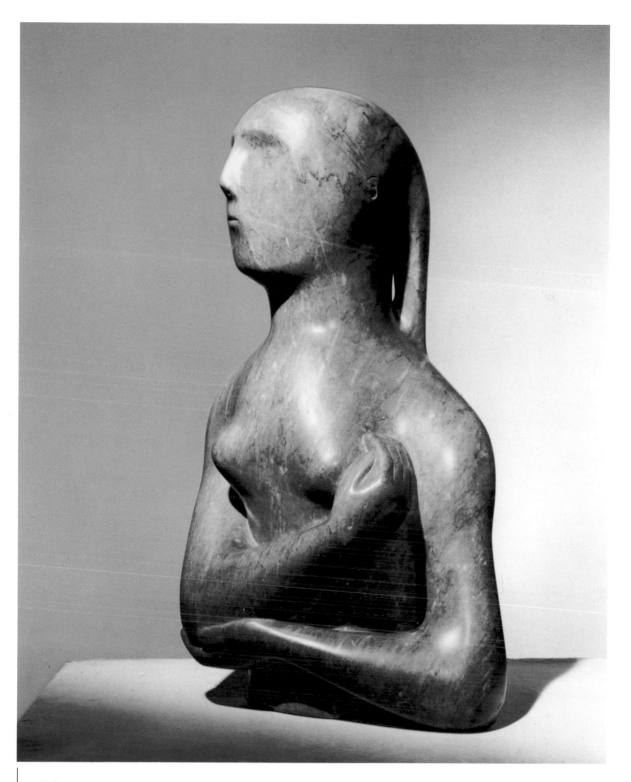

Half-figure 1932 Armenian marble H. 27 in.
Tate Gallery, London, Bequest of E. C. Gregory

▷

Mother and Child
1931
Sycamore wood
H. 30 in.
Soprintendenza Per I Beni
Artistici E Storici, Milan

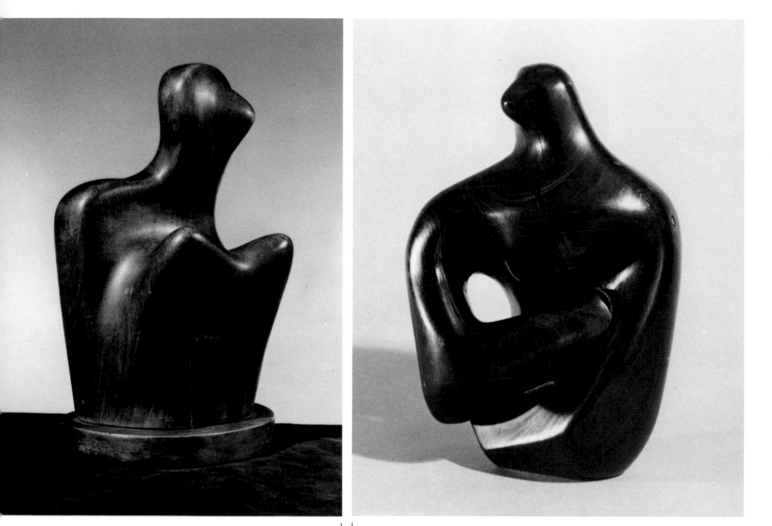

Figure
1931
Beech wood
H. 9¾ in.
Tate Gallery, London, Bequest of E. C. Gregory

Figure
1932
Lignum vitae wood
H. 10 in.
The University of Michigan Museum of Art, Ann Arbor

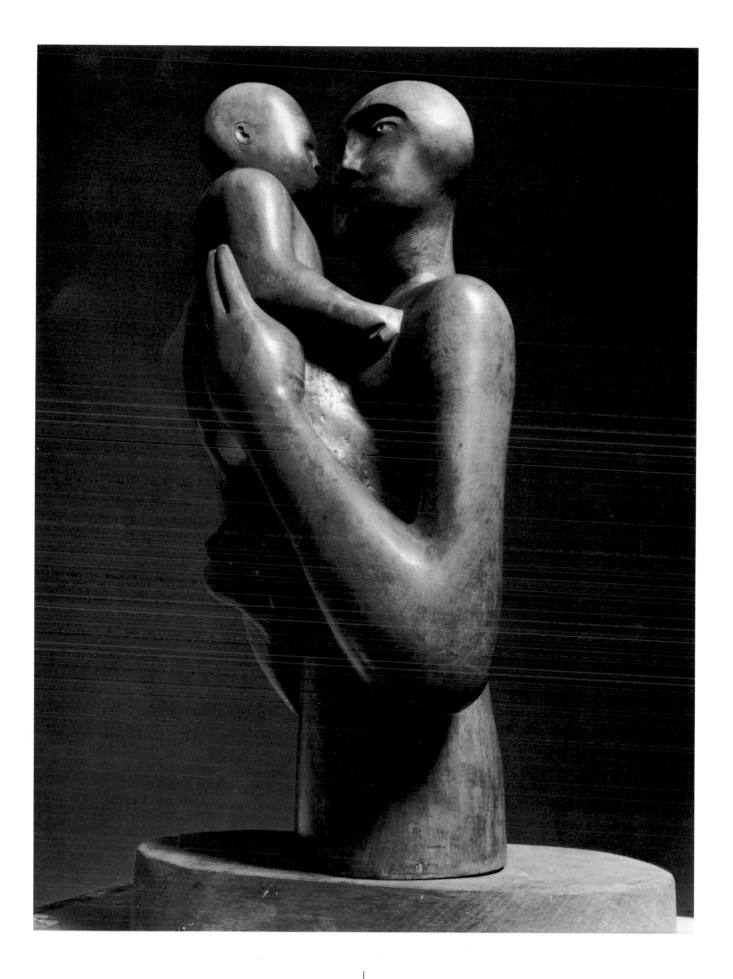

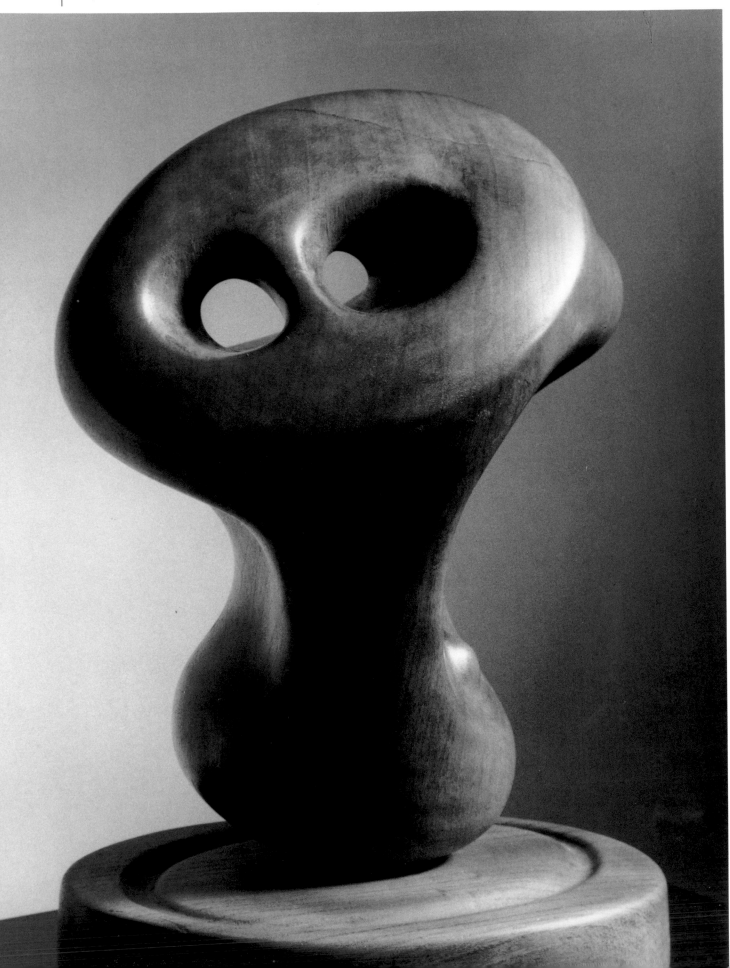

Composition 1934
Bronze L. 20½ in.
Arts Council of Great Britain, Purchase

Head and Ball 1934
Cumberland alabaster L. 20 in.
Mrs. Allan D. Emil, New York

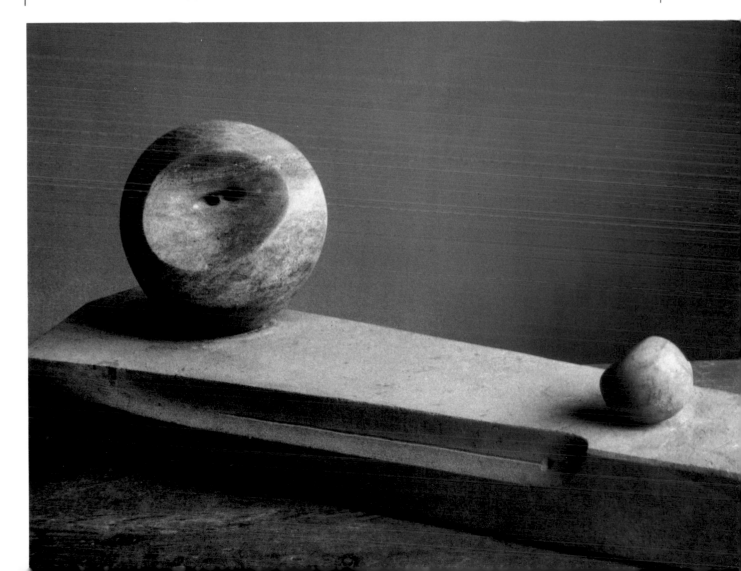

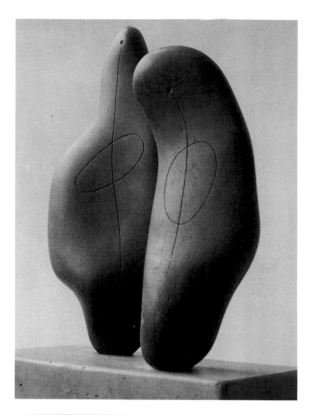

◁
Two Forms 1934 Ironstone H. 7¼ in.
Private Collection
▽
Studies for Sculpture 1934 Wash and charcoal 14⅞ x 22 in.
The Museum of Modern Art, New York,
Acquired through the Lillie P. Bliss Bequest

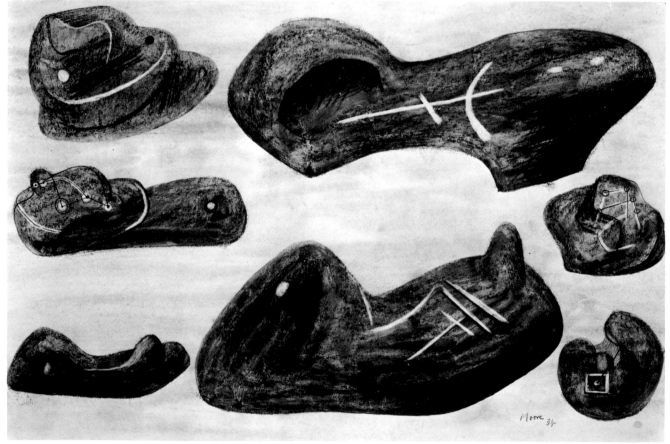

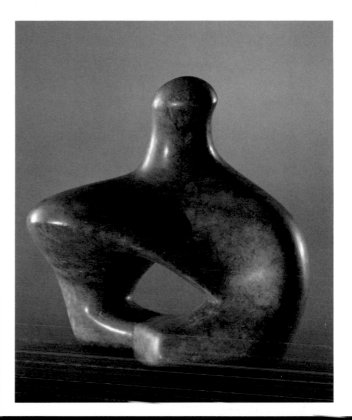

▷
Carving 1935 Cumberland alabaster H. 13½ in.
The Hirshhorn Museum and Sculpture Garden,
Washington, D.C.

▽
Reclining Figure 1934-35 Corsehill stone L. 24½ in.
The Henry Moore Foundation

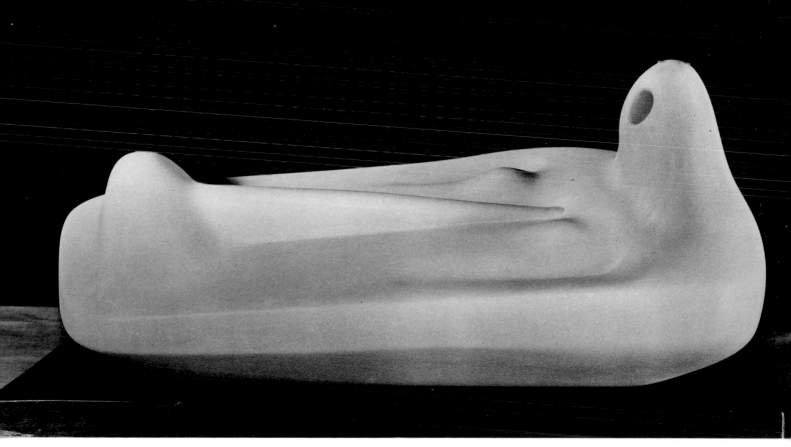

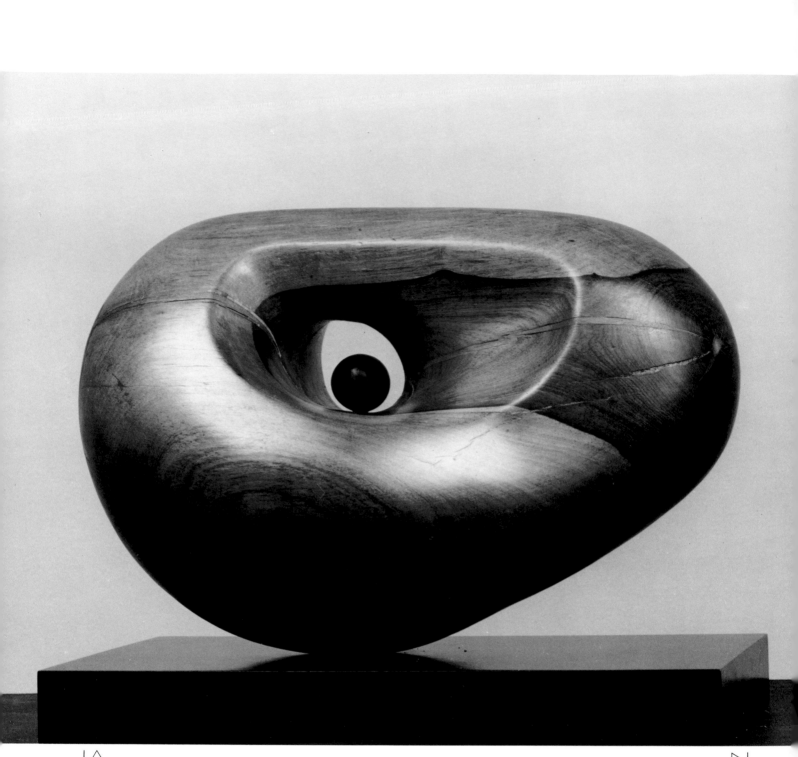

△
Carving
1935
African wood
L. 16 in.
Private Collection

▷
Carving
1936
Travertine marble
H. 18 in.
The Henry Moore Foundation

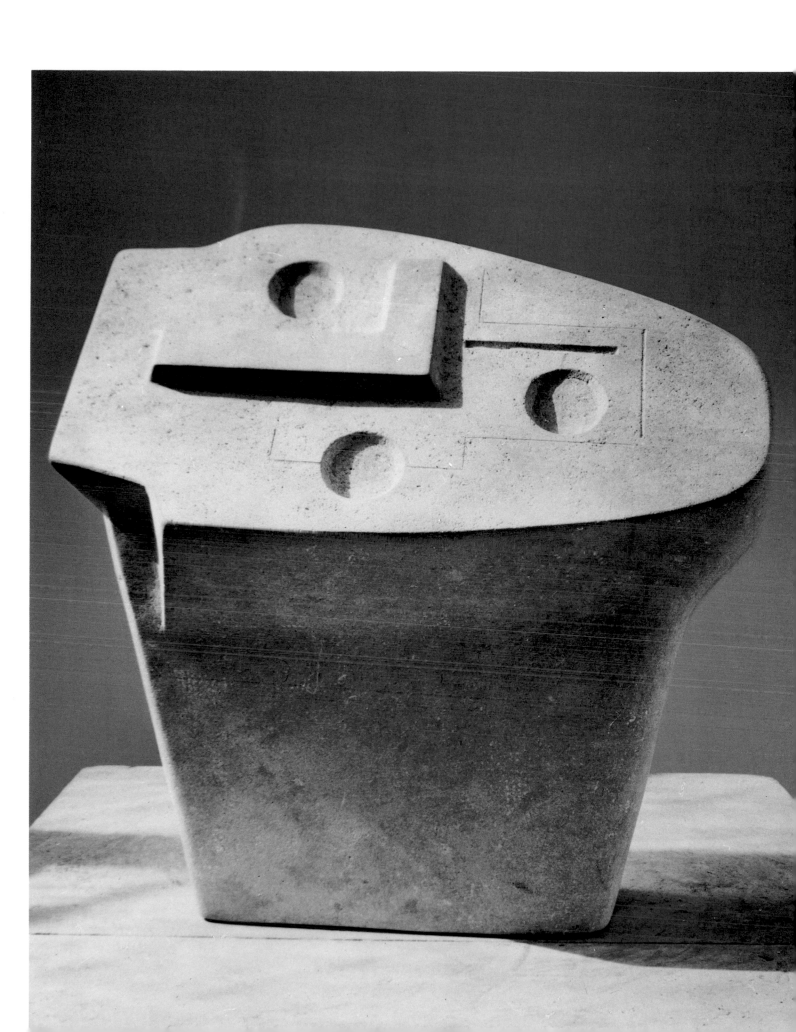

▽

Four Forms
1936
African wonderstone
L. 22 in.
Mr. and Mrs. Henry R. Hope, Fort Lauderdale

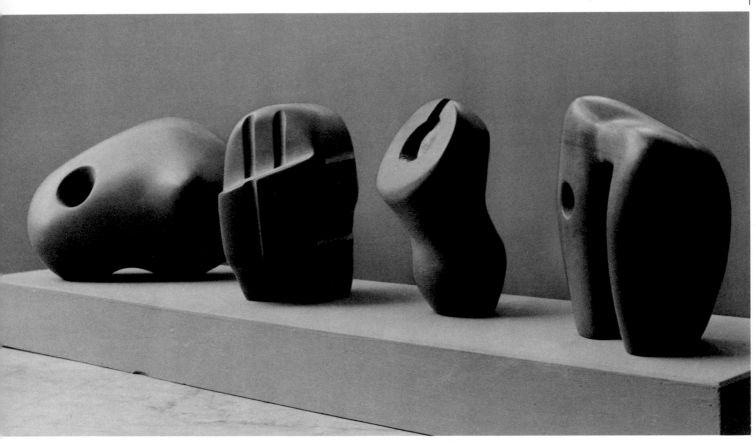

▷

Ideas for Stone Sculpture
1937
Pen and ink, chalk, and wash
11⅛ x 8¾ in.
Private Collection

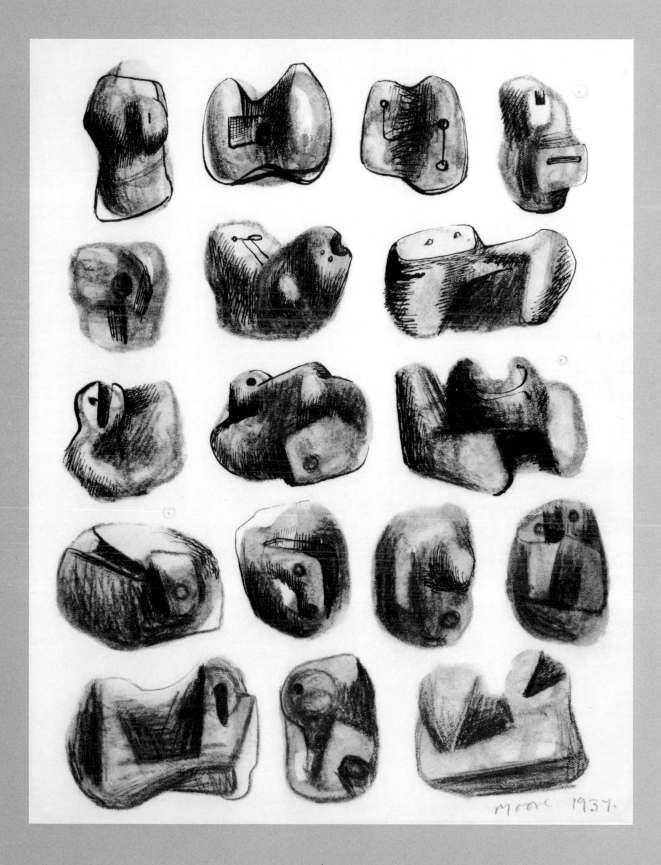

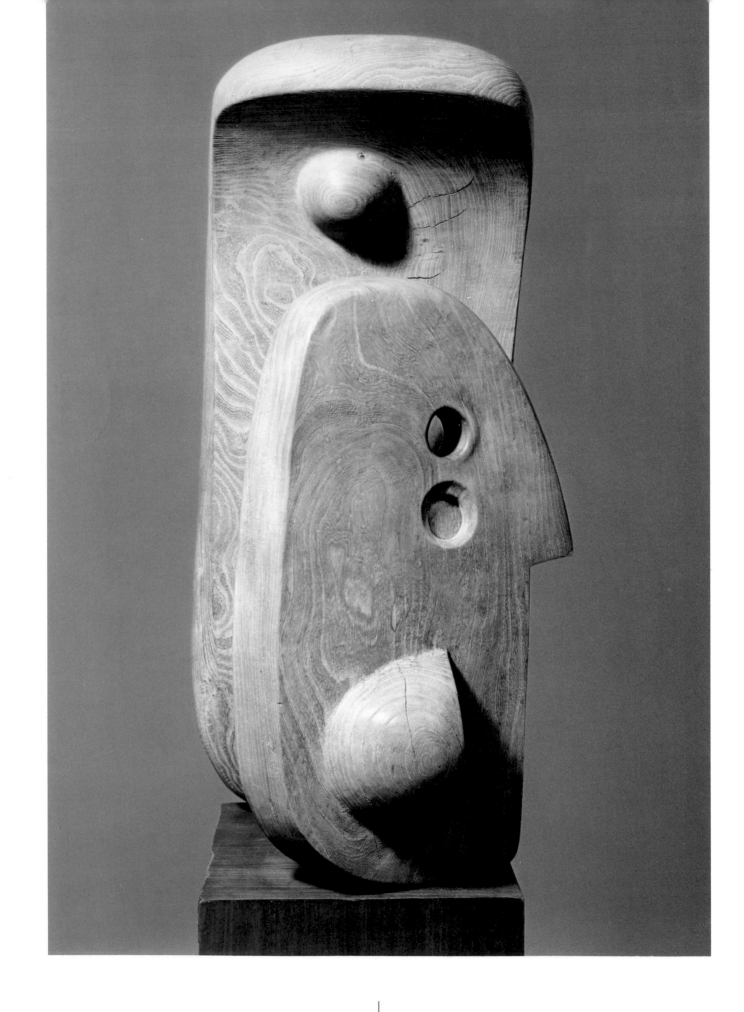

◁
Mother and Child
1938
Elm wood
H. 30⅜ in.
The Museum of Modern Art, New York,
Acquired through the Lillie P. Bliss Bequest

▽
Reclining Figure
1935-36
Elm wood
L. 35 in.
Albright-Knox Art Gallery, Buffalo, N.Y., Room of Contemporary Art Fund

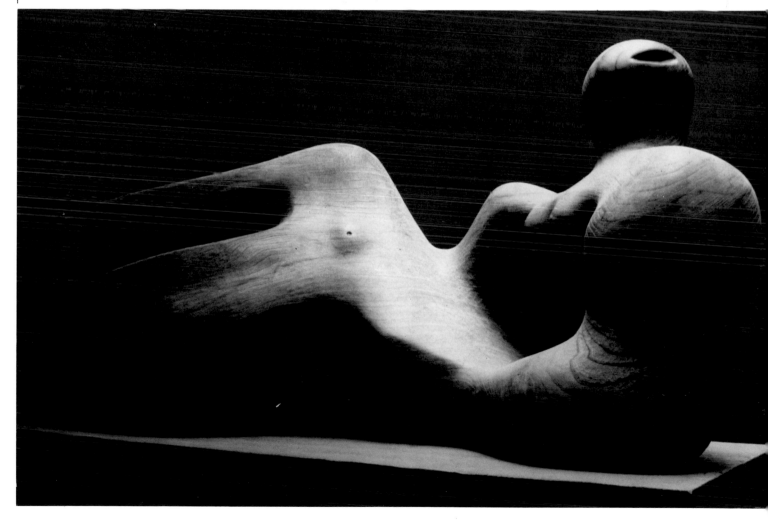

Opposite: ▷
Two Forms
1936
Hornton stone
H. 42 in.
Philadelphia Museum of Art,
Gift of Mrs. H. Gates Lloyd

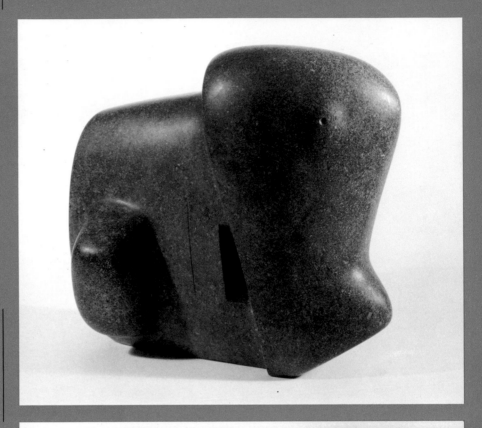

▷
Figure
1937
Bird's-eye marble
L. 20 in.
The Saint Louis Art Museum,
Gift of Mr. and Mrs. Morton D. May

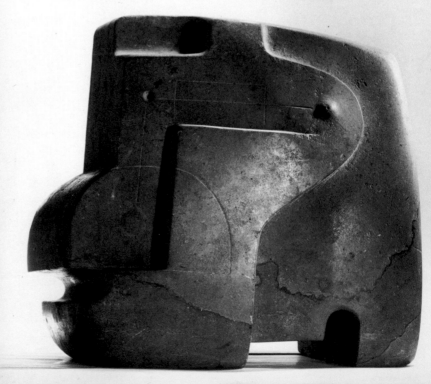

▷
Square Form
1936
Green Hornton stone
L. 16 in.
The University of East Anglia,
Norwich, England,
The Robert and Lisa Sainsbury
Collection

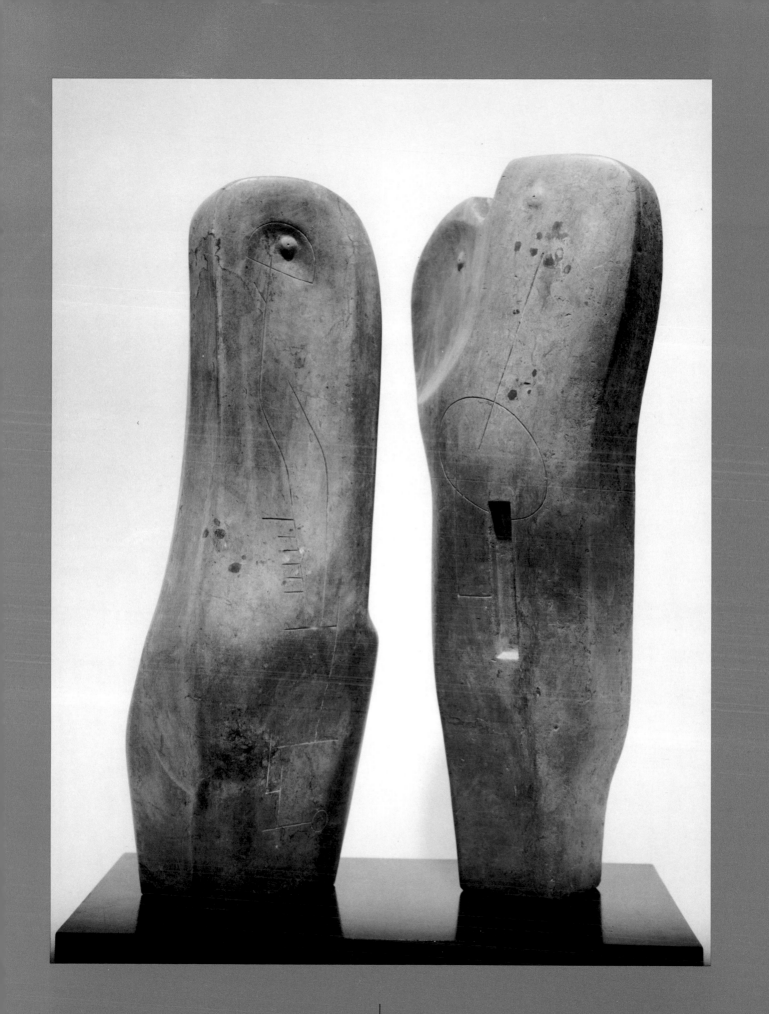

Stringed Forms

▷
Stringed Figure
1937
Cherry wood and string
H. 20 in.
The Henry Moore Foundation

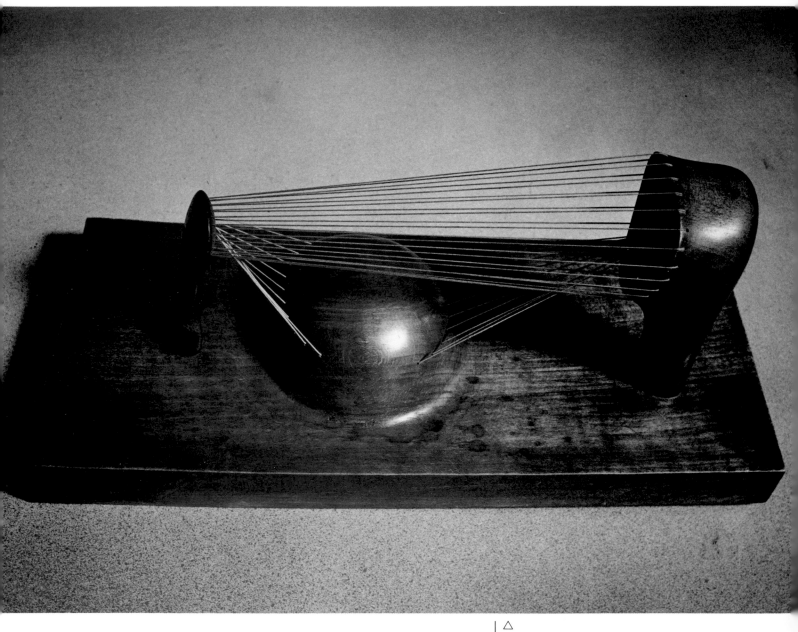

△
Stringed Relief
1937
Beech wood and string
L. 19½ in.
Mr. and Mrs. Nathan Smooke, Los Angeles

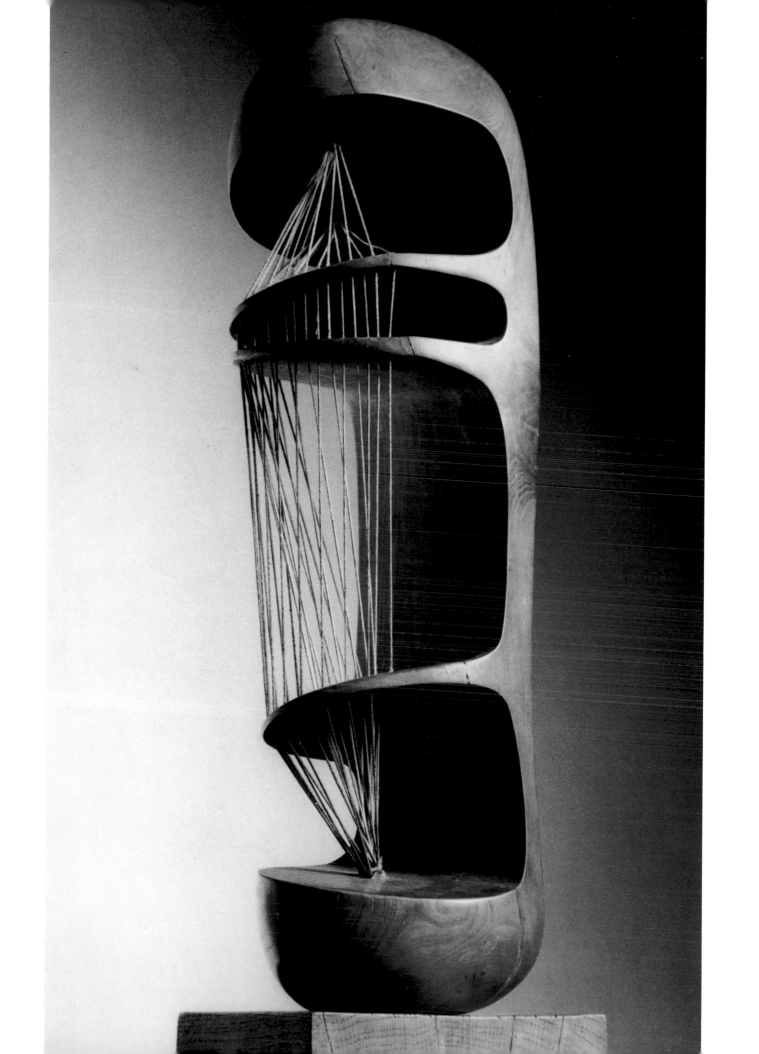

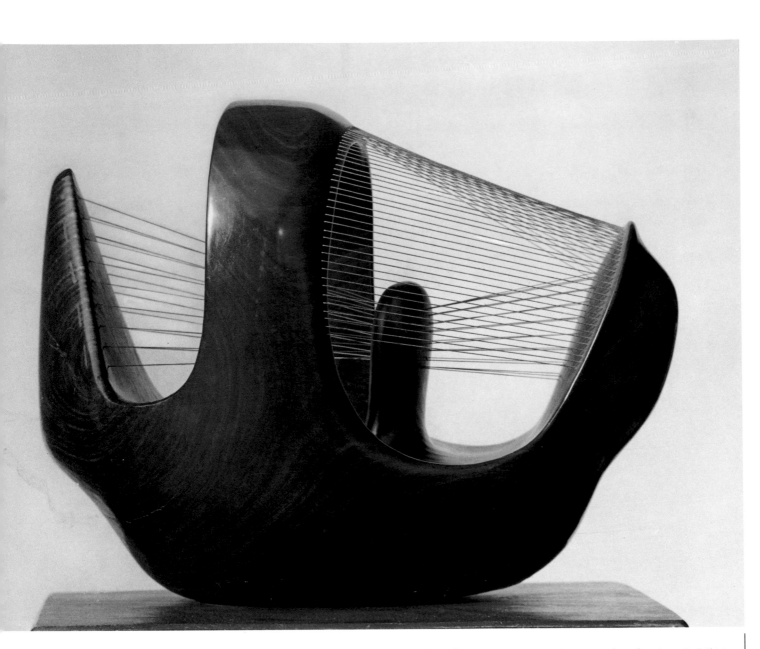

Bird Basket 1939 Lignum vitae wood and string L. 16½ in.
Private Collection

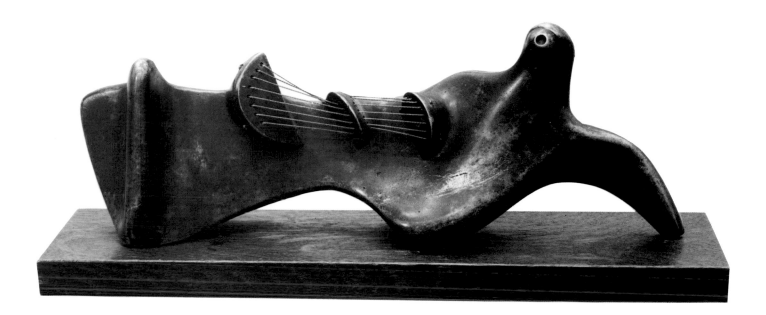

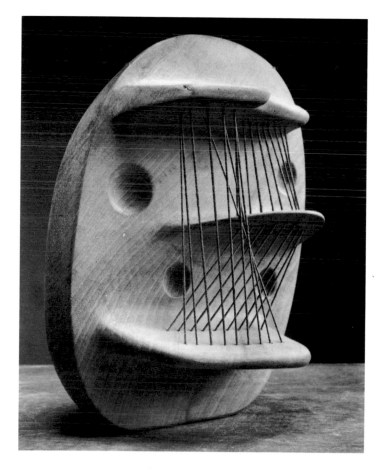

△
Stringed Reclining Figure 1939 Bronze and string L. 10 in.
The University of Michigan Museum of Art, Ann Arbor,
Bequest of Florence L. Stol
◁
Stringed Head 1938 Elm wood and string H. 8 in.
Ursula and Erno Goldfinger and Family, London

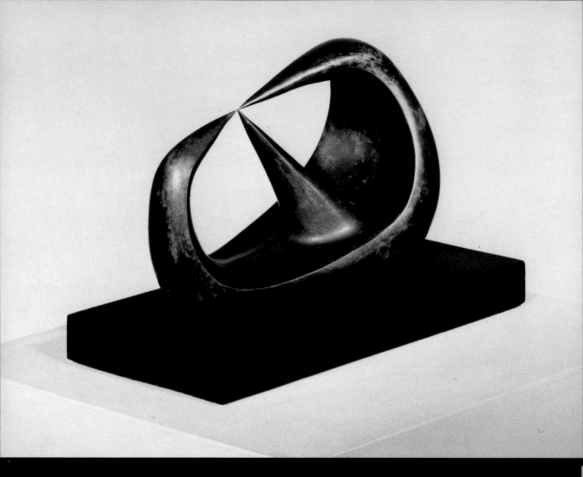

Wartime Drawings

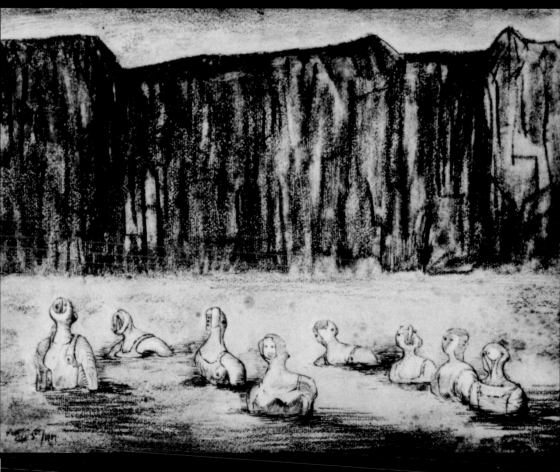

September 3rd 1939
1939
Pencil, pen and ink, chalk, crayon, and watercolor
11⅜ x 15⅝ in.
The Henry Moore Foundation

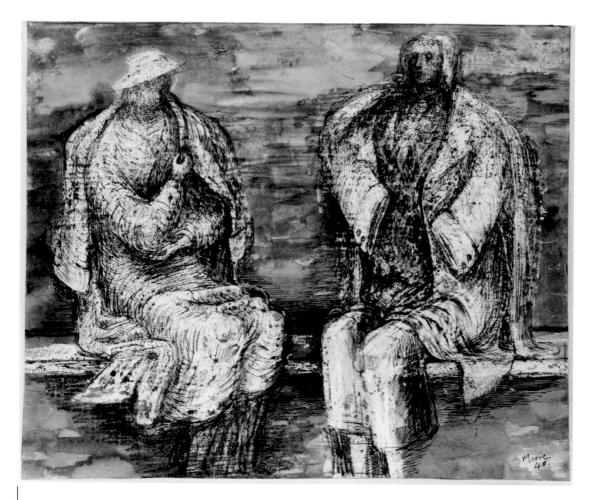

Two Women on a Bench in a Shelter 1940 Pen and ink, wax crayon, chalk, and wash 13⁷⁄₁₆ x 16¹⁄₁₆ in.
Art Gallery of Ontario, Toronto, Purchase

Three Seated Figures 1940 Pen and ink, colored crayons, and watercolor 11⁵⁄₈ x 15⁹⁄₁₆ in.
The Art Institute of Chicago, Gift of Mr. and Mrs. Joel Starrels

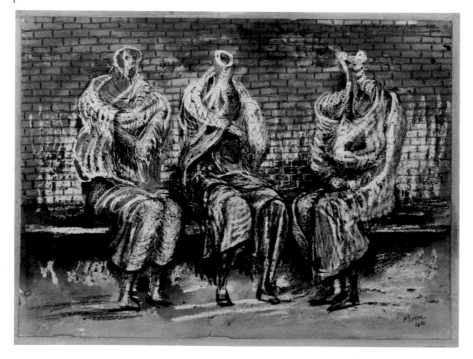

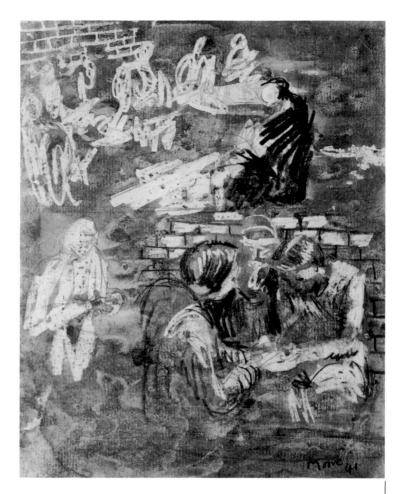

Women and Children in Bombed-Out Building 1941 Crayon and pen and ink 7⅛ x 6¼ in.
Charlotte Bergman, Jerusalem

Shelter Scene: Two Reclining Figures 1941 Crayon and pen and ink 12 x 13 in.
Charlotte Bergman, Jerusalem

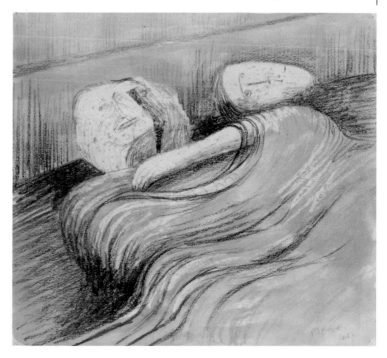

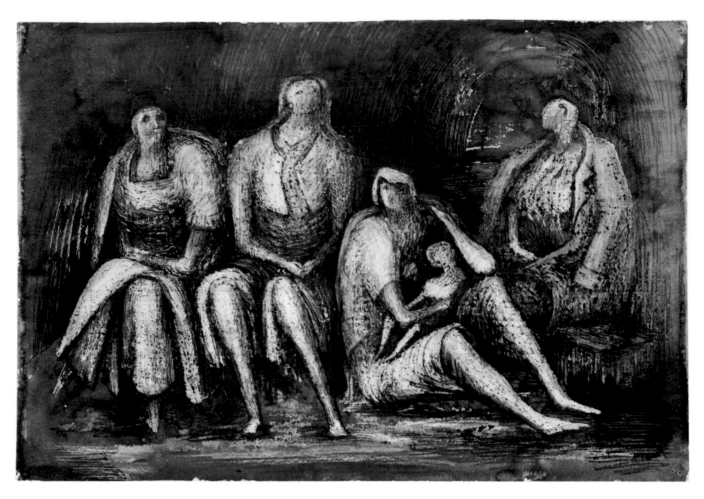

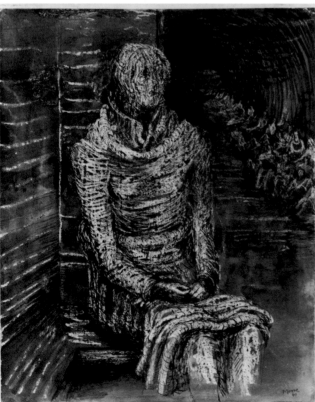

△
Group of Shelterers During an Air Raid
(1941)
Pen and ink, wax crayon, chalk, and watercolor
15 x 21⅞ in.
Art Gallery of Ontario, Toronto,
Gift of the Contemporary Art Society
◁
Woman Seated in the Underground Shelter
1941
Pencil, pen and brush and ink,
crayon, and gouache
19 x 15 in.
Tate Gallery, London, Presented by
War Artists' Advisory Committee

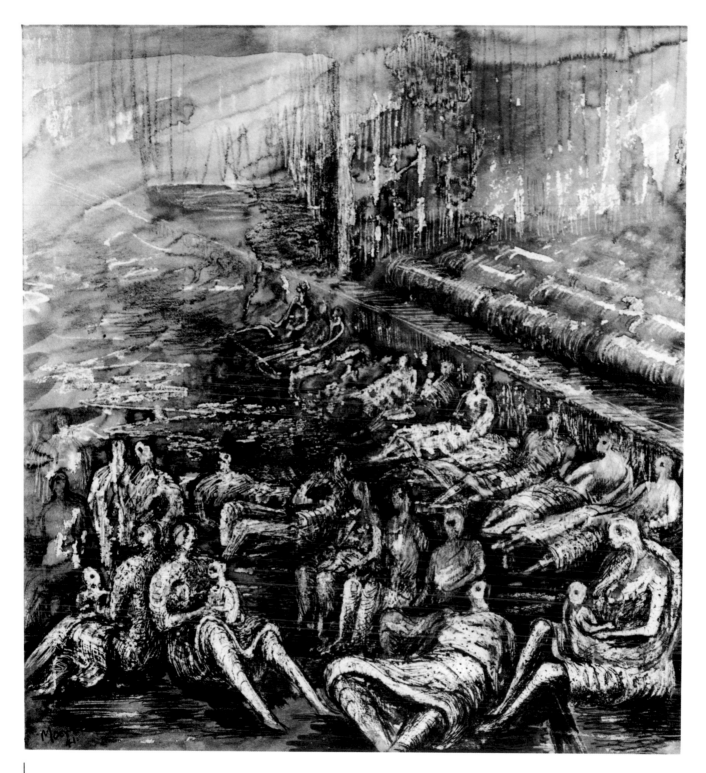

A Tilbury Shelter Scene
1941
Pencil, pen and brush and ink, crayon, and gouache
16½ x 15 in.
Tate Gallery, London, Presented by War Artists' Advisory Committee

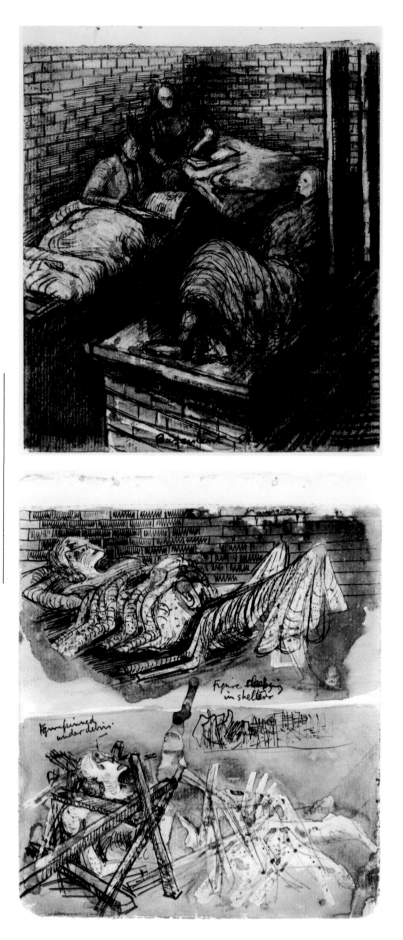

Second Shelter Sketchbook: Basement Shelter
(1941)
Pencil, colored crayons, and pen and ink
8 x 6½ in.
The Henry Moore Foundation

Second Shelter Sketchbook:
Sleeping Figure and Figure Pinned under Debris
(1941)
Pencil, wax crayons, watercolor,
and pen and ink
8 x 6½ in.
The Henry Moore Foundation

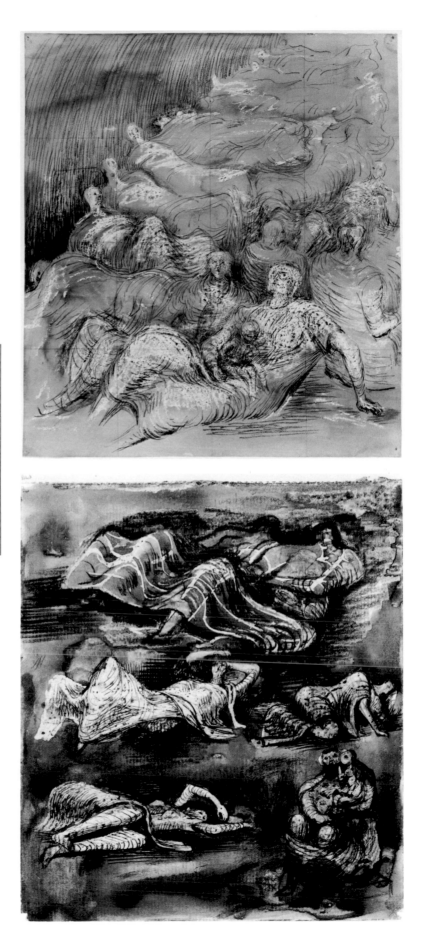

Pale Shelter Scene
(1941)
Pen and ink, chalk, watercolor,
and gouache
19 x 17 in.
Tate Gallery, London, Presented by
War Artists' Advisory Committee

Second Shelter Sketchbook: Study for Shelter Drawing
(1941)
Pencil, wax crayons, watercolor, and pen and ink
8 x 6½ in.
The Henry Moore Foundation

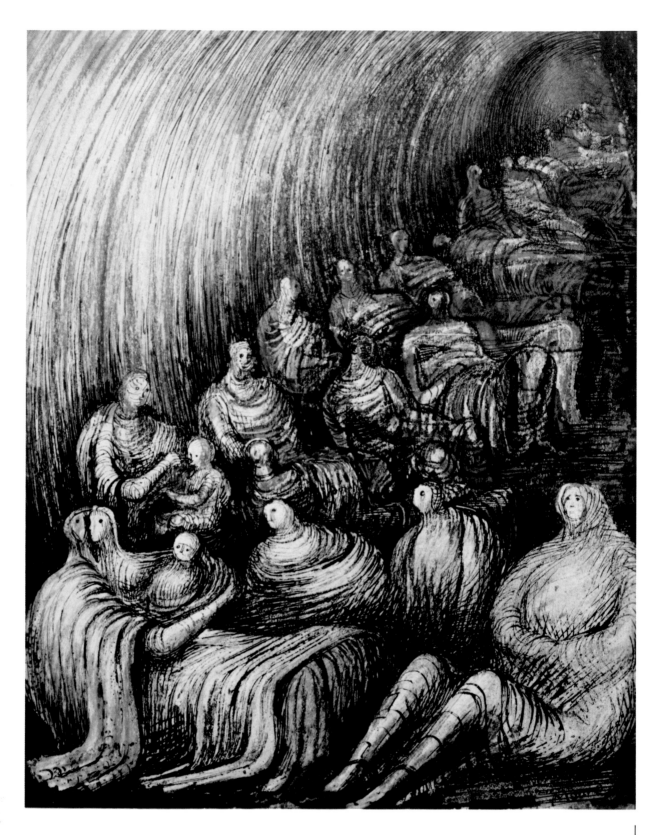

Shelter Scene
(1941)
Wash and pen and brush and ink
10 x 8 in.
Lockwood Thompson, Cleveland

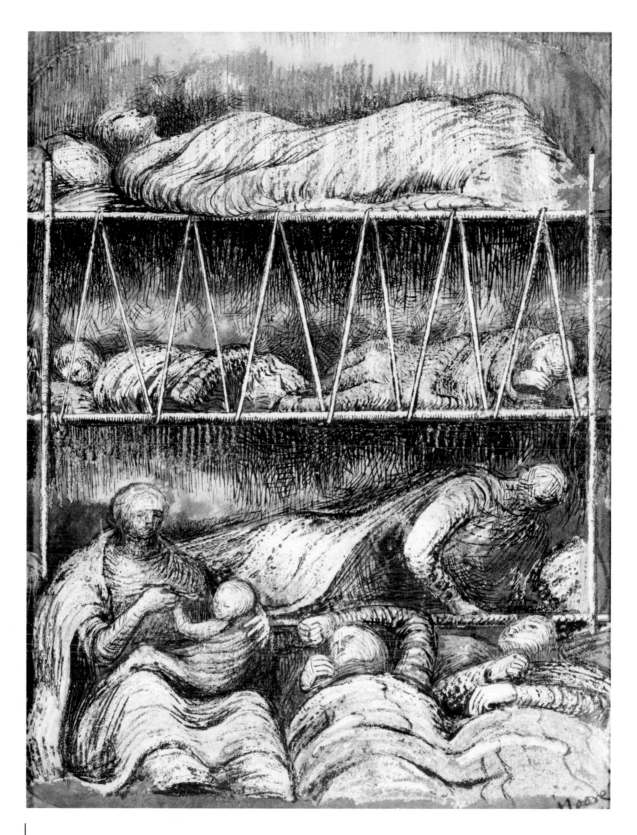

Shelter Scene: Bunks and Sleepers
(1941)
Wash and pen and brush and ink
10 x 8 in.
Lockwood Thompson, Cleveland

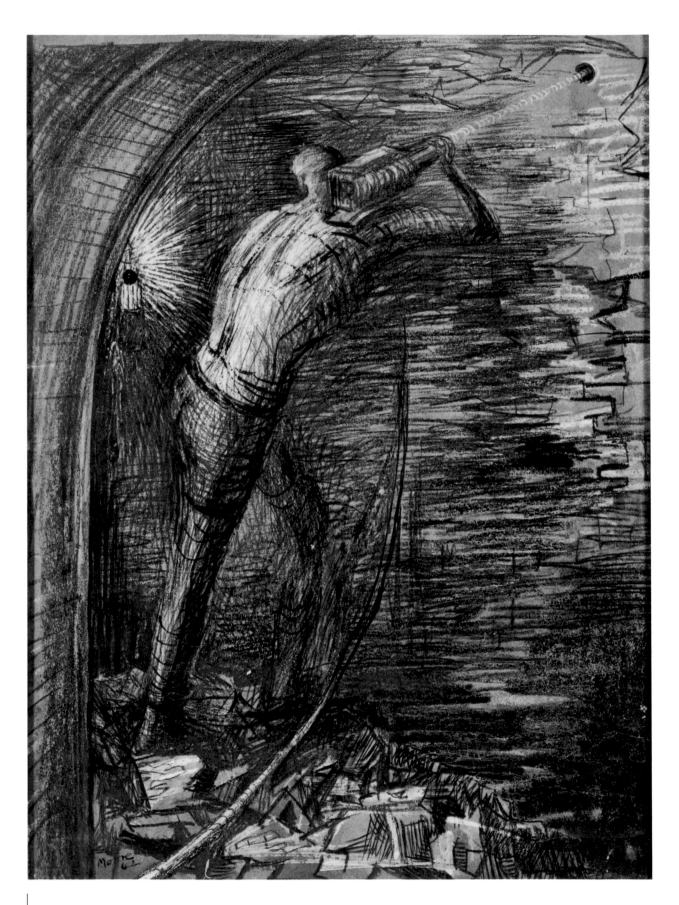

Miner at Work 1942 Pen and ink, crayon, and watercolor 25⅛ x 19¹⁵⁄₁₆ in.
The Portland Art Museum, Oregon, Gift of Dr. Francis Newton

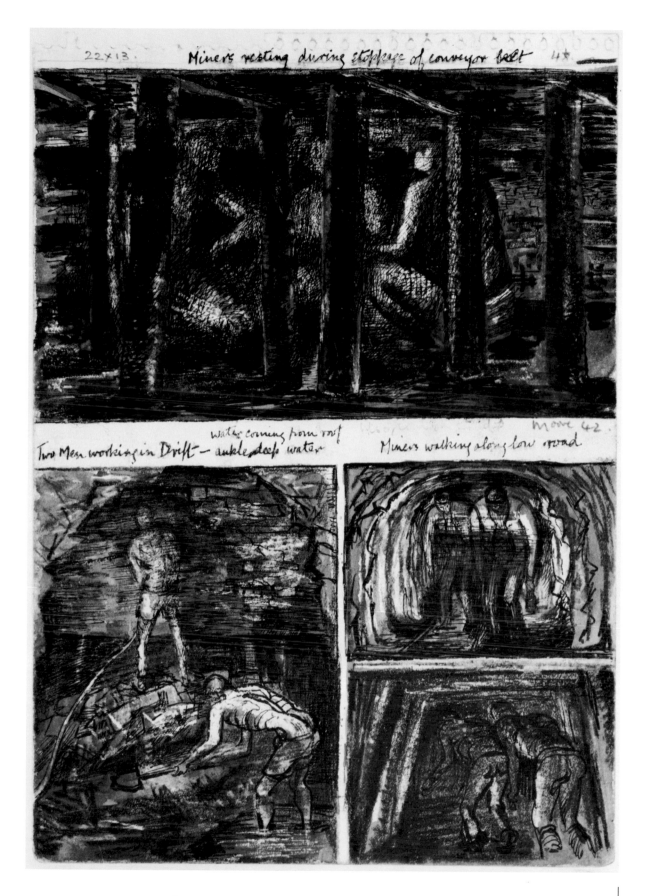

Page from a Coalmine Sketchbook: Study for Miners Resting During Stoppage of Conveyor Belt
Pen and ink, crayon, wash, and pencil 9⅞ x 6¹⁵⁄₁₆ in.
Art Gallery of Ontario, Toronto, Gift of the artist

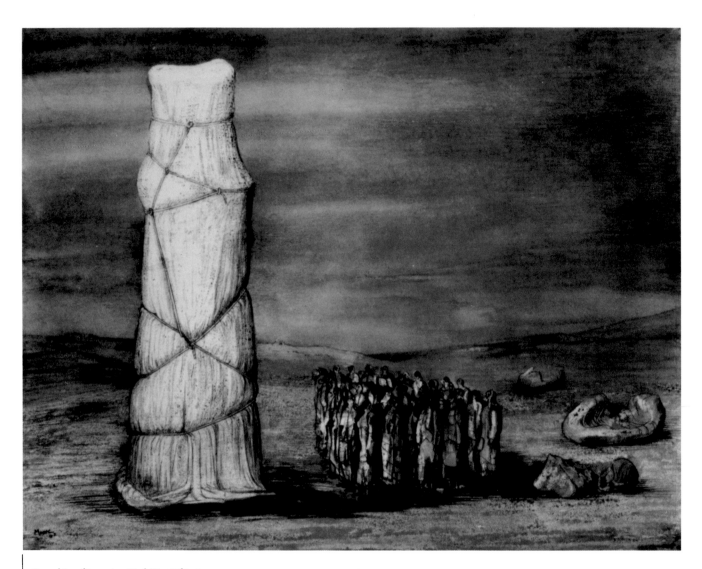

Crowd Looking at a Tied-Up Object
1942
Pencil, chalk, crayon, and wash
15¾ x 21⅝ in.
Lord Clark of Saltwood, England

Principal Themes

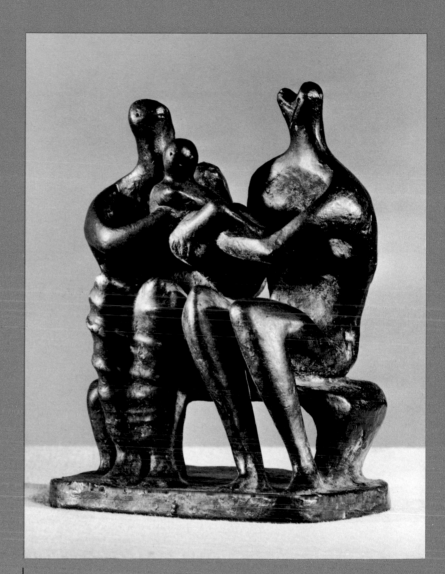

Family Group (working model)
1945
Bronze
H. 9⅜ in.
The Jeffrey H. Loria Collection, New York

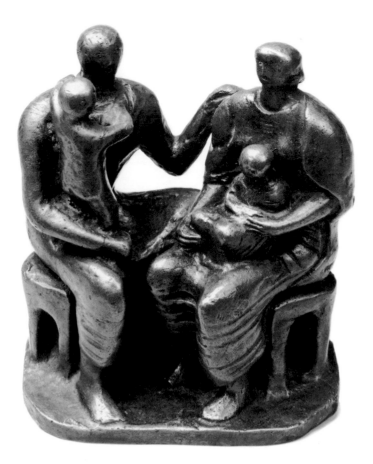

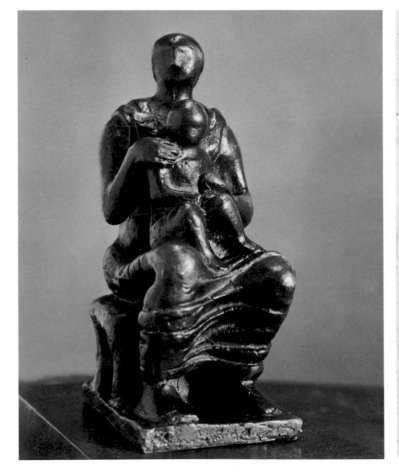

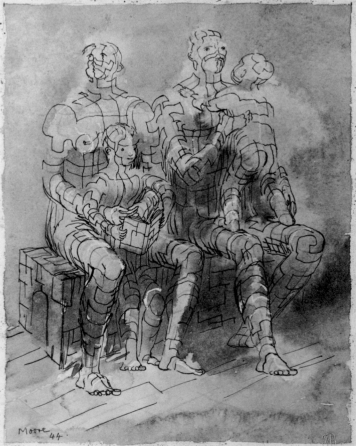

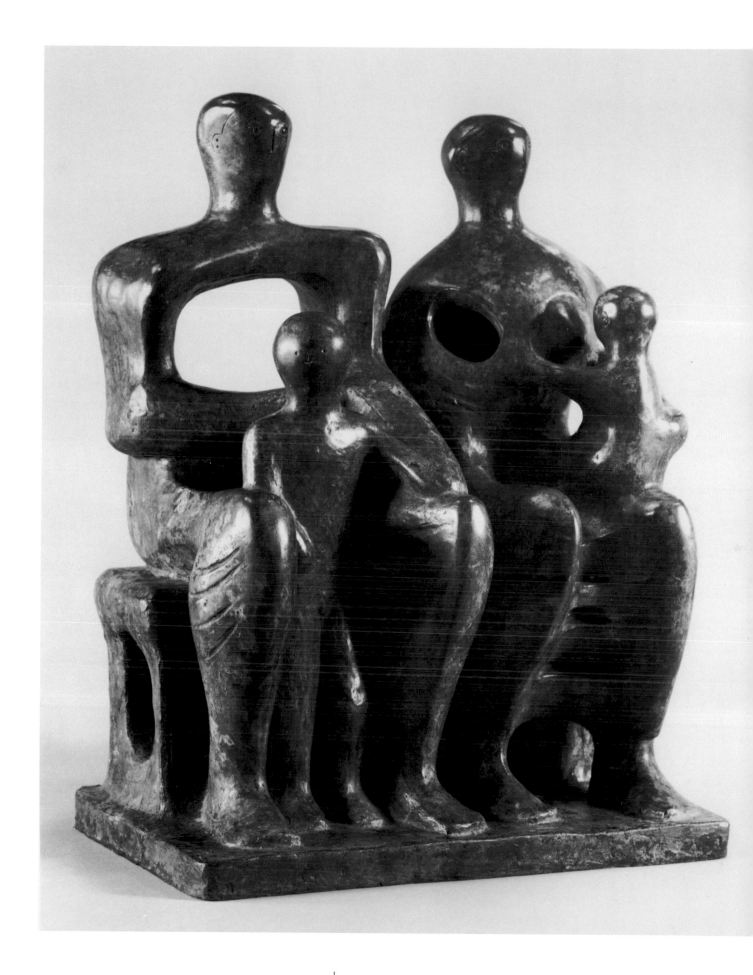

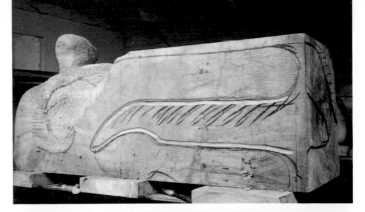

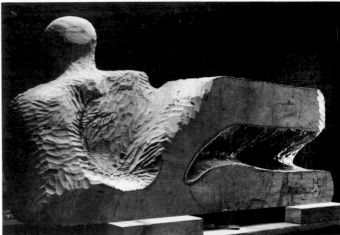

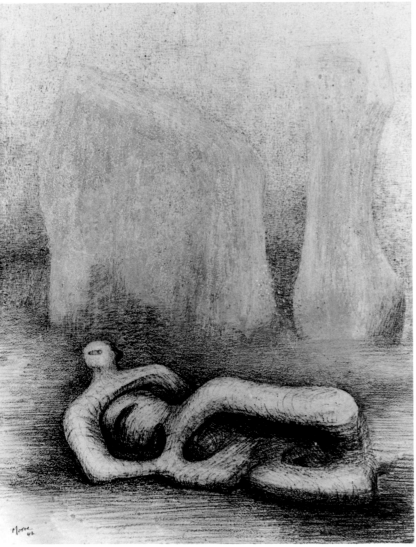

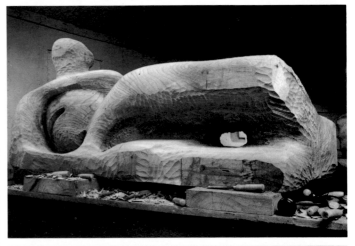

△
Reclining Figure and Pink Rocks
1942
Crayon
22 x 16½ in.
Albright-Knox Art Gallery, Buffalo, N.Y.,
Room of Contemporary Art Fund

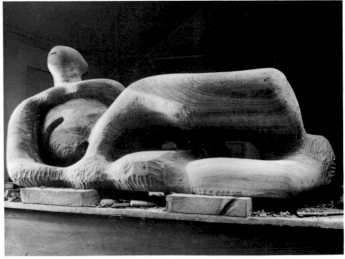

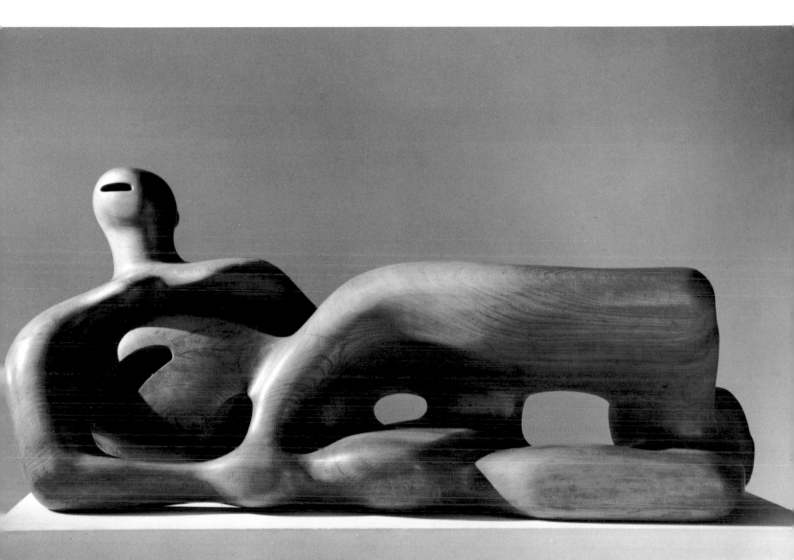

△
Reclining Figure
1945-46
Elm wood
L. 75 in.
Private Collection
◁
Work in progress: Reclining Figure

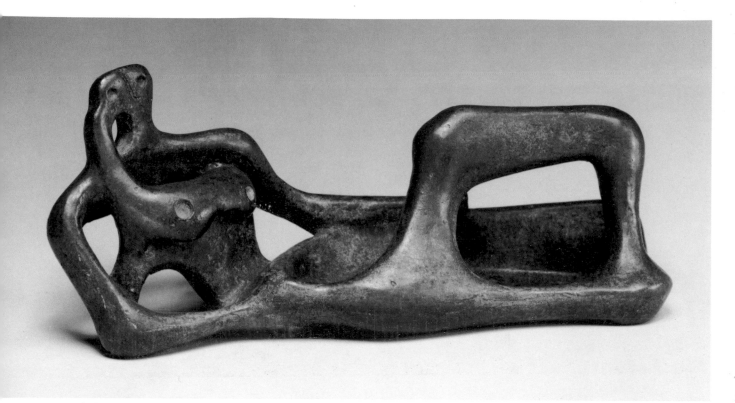

△
Reclining Figure (sketch model) 1945 Bronze L. 7 in. Private Collection
▽
Reclining Figure 1946-47 Brown Hornton stone L. 27 in. Mr. and Mrs. Henry R. Hope, Fort Lauderdale

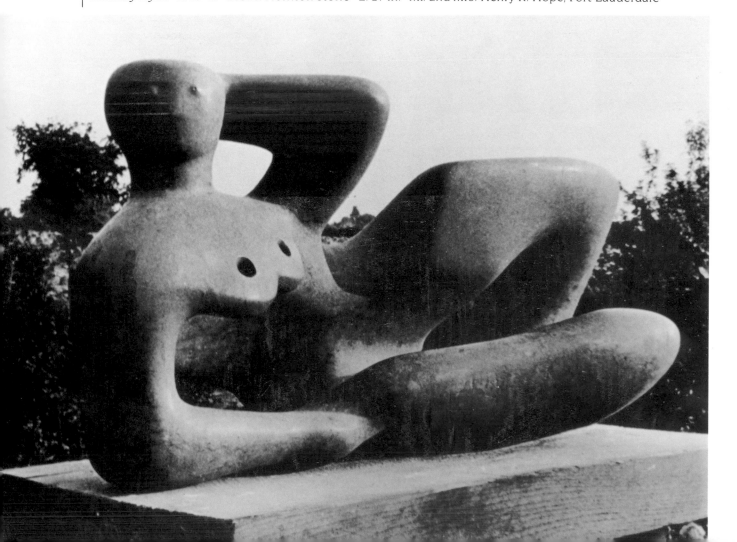

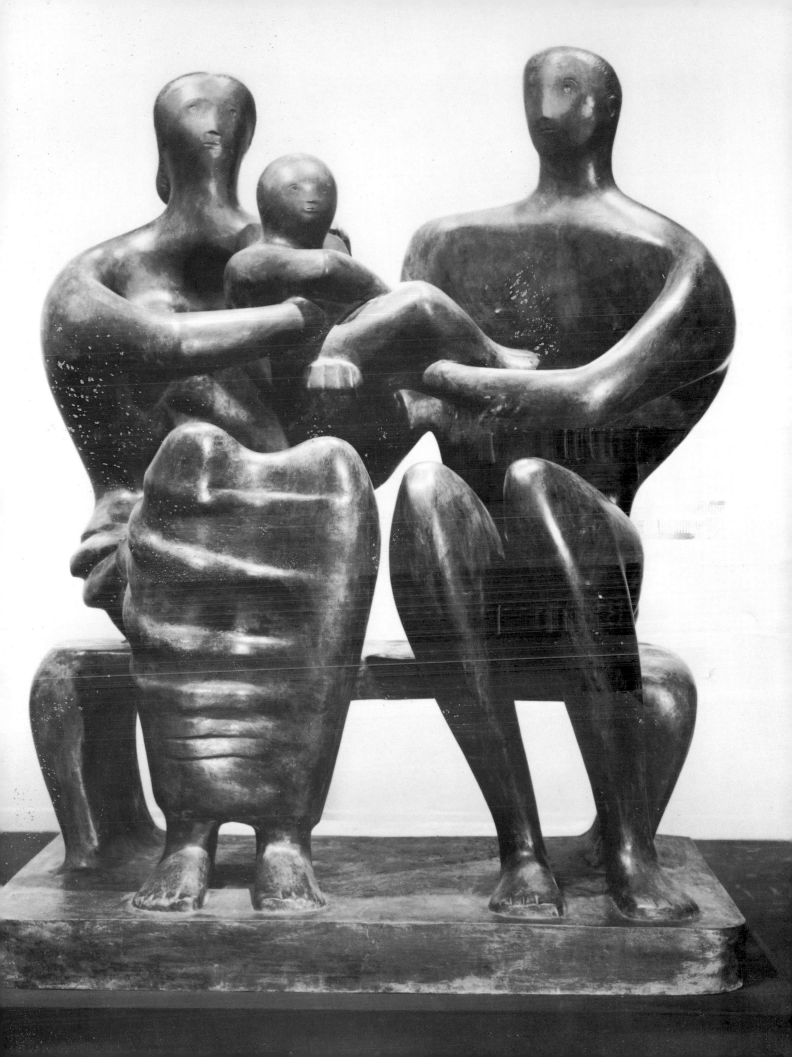

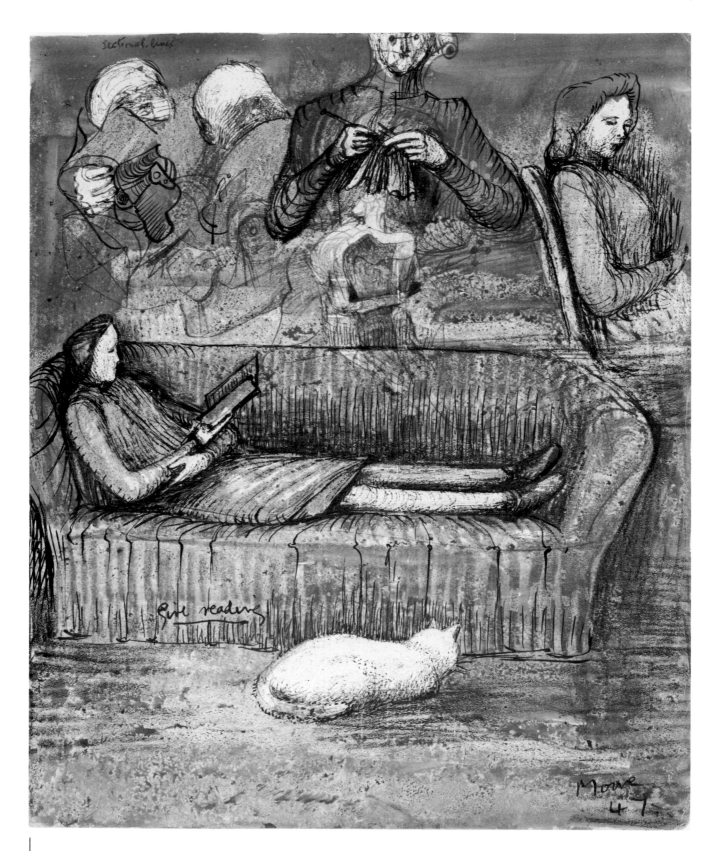

Woman Knitting and Girl Reading 1947 Watercolor, pen and ink, crayon, and pencil 11½ x 9½ in.
The Museum of Modern Art, New York, The Joan and Lester Avnet Collection

Preceding page:
Family Group 1948-49 Bronze H. 59¼ in.
The Museum of Modern Art, New York Purchase, A Conger Goodyear Fund

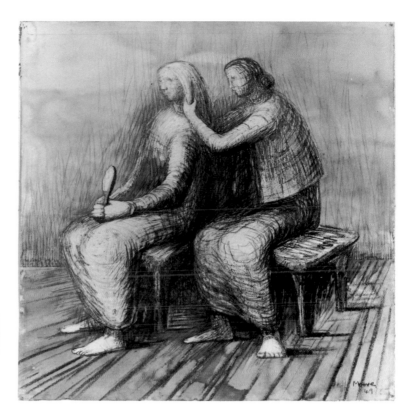

Woman Having Her Hair Combed
1949
Wash, charcoal, and pen and ink
23 x 22 in.
The Jeffrey H. Loria Collection, New York

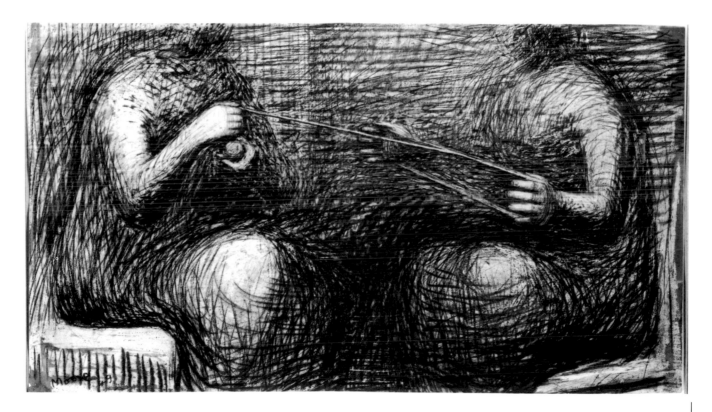

Women Winding Wool
1949 Crayon and watercolor 13¾ x 25 in.
The Museum of Modern Art, New York, Gift of Mr. and Mrs. John A. Pope in honor of Paul J. Sachs

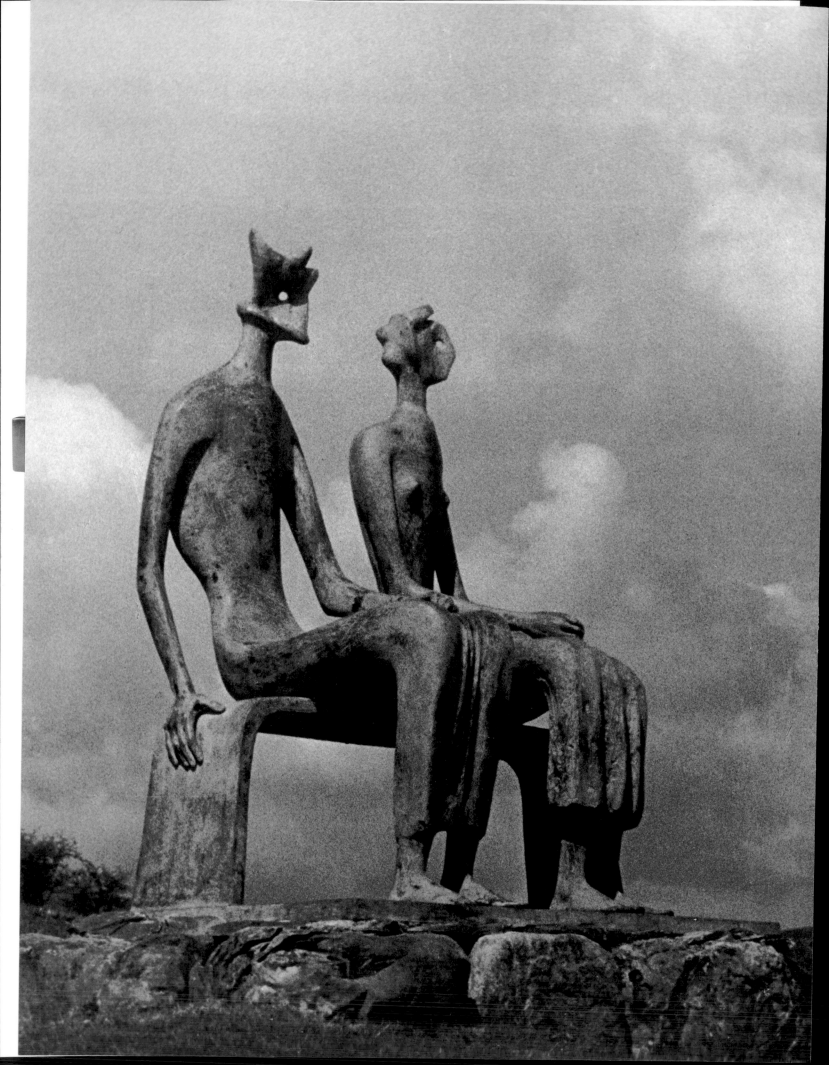

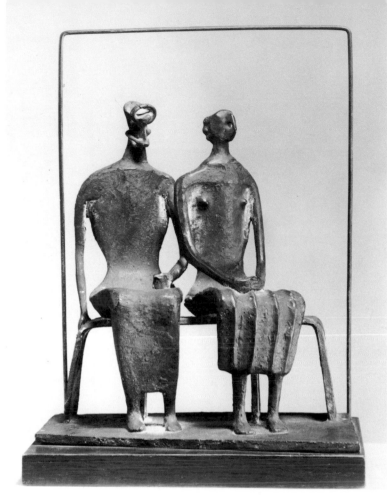

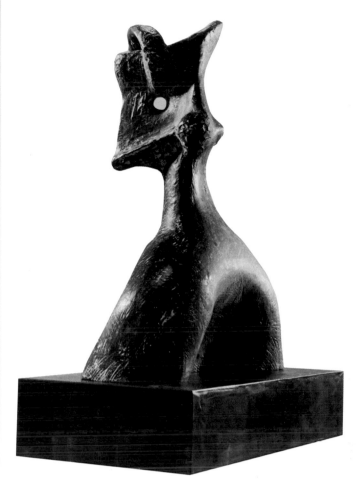

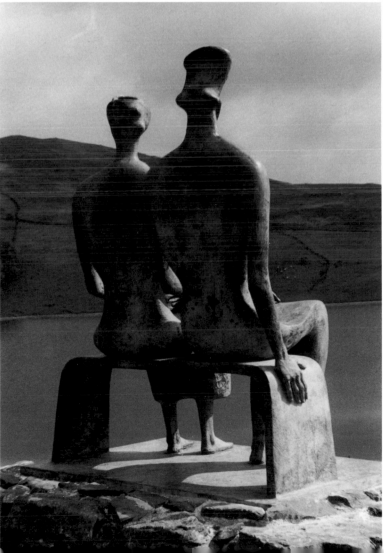

Top left:
King and Queen (maquette)
1952
Bronze
H. 10½ in.
Mr. and Mrs. William R. Acquavella,
New York

Top right:
Head of King
1952-53
Bronze (unique cast)
H. 23 in.
Arts Council of Great Britain, Purchase

Opposite:
King and Queen
1952-53
Bronze
H. 63½ in.
Tate Gallery, London,
Presented by Friends of Tate Gallery
with funds from Assoc.
Rediffusion Ltd.

Left:
Rear View: King and Queen

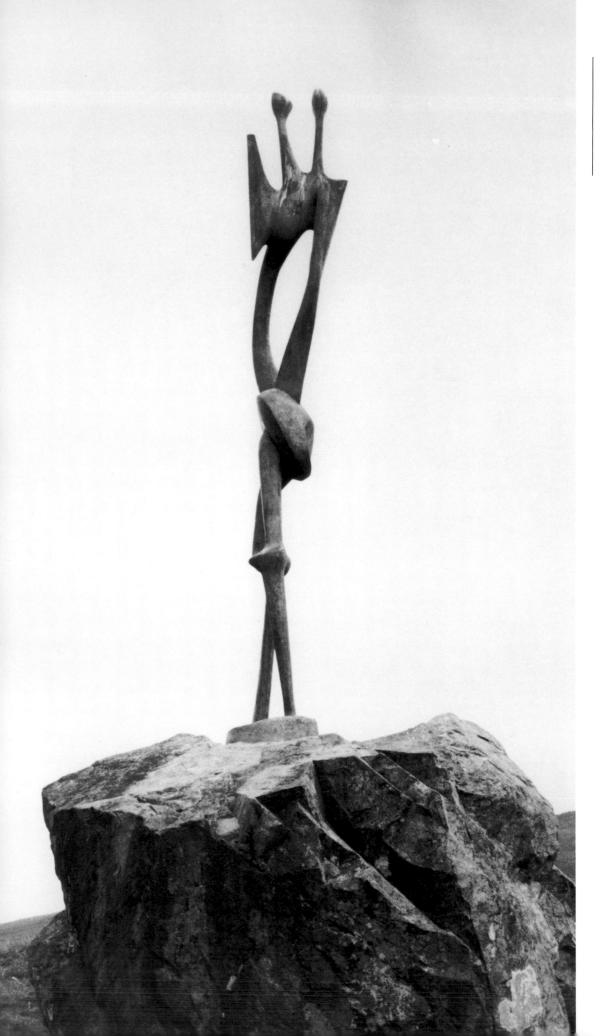

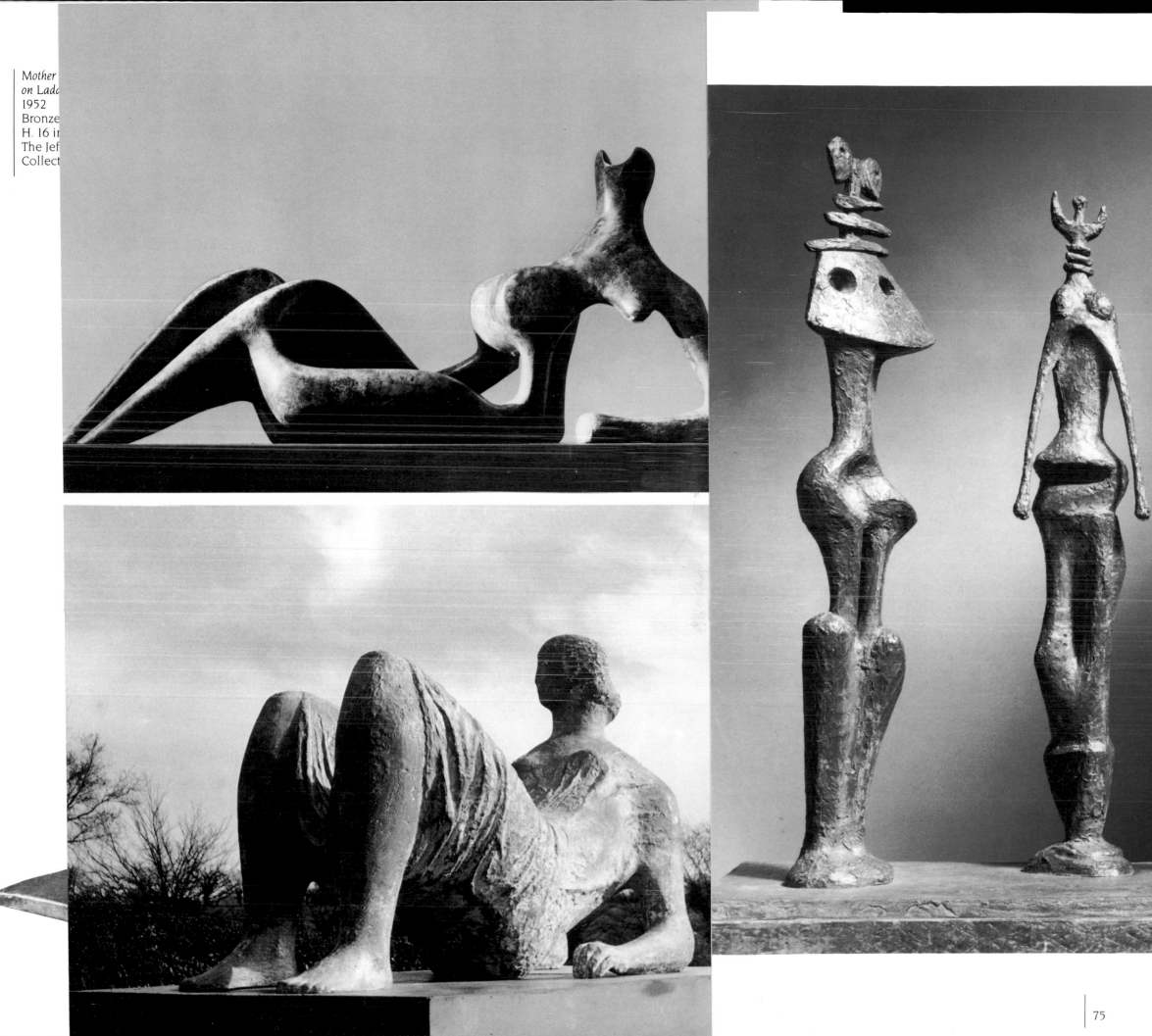

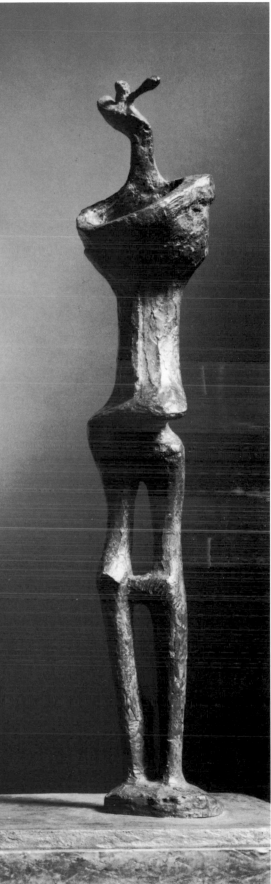

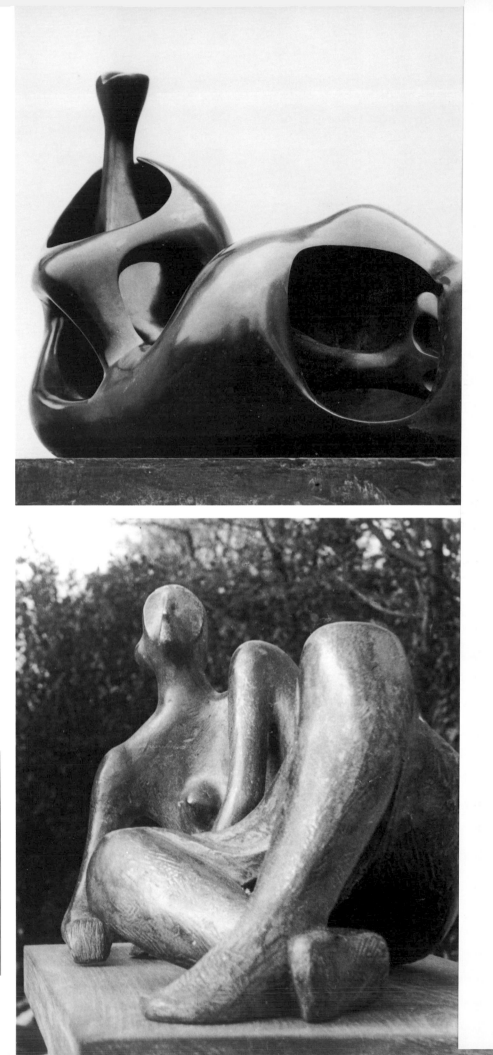

Right:
Reclining Figure
(working model)
1951
Bronze
L. 21 in.
The Jeffrey H. Loria
Collection, New York

Opposite right:
Reclining Figure
(maquette)
1950
Bronze
L. 17⅜ in.
Muriel Kallis Newman,
Chicago

Right:
Reclining Figure, no. 4
1954-55
Bronze
L. 23¼ in.
Mr. and Mrs. Leonard S. Field,
New York

Opposite right:
Draped Reclining Figure
1952-53
Bronze
L. 66½ in.
The Hirshhorn Museum
and Sculpture Garden,
Washington, D.C

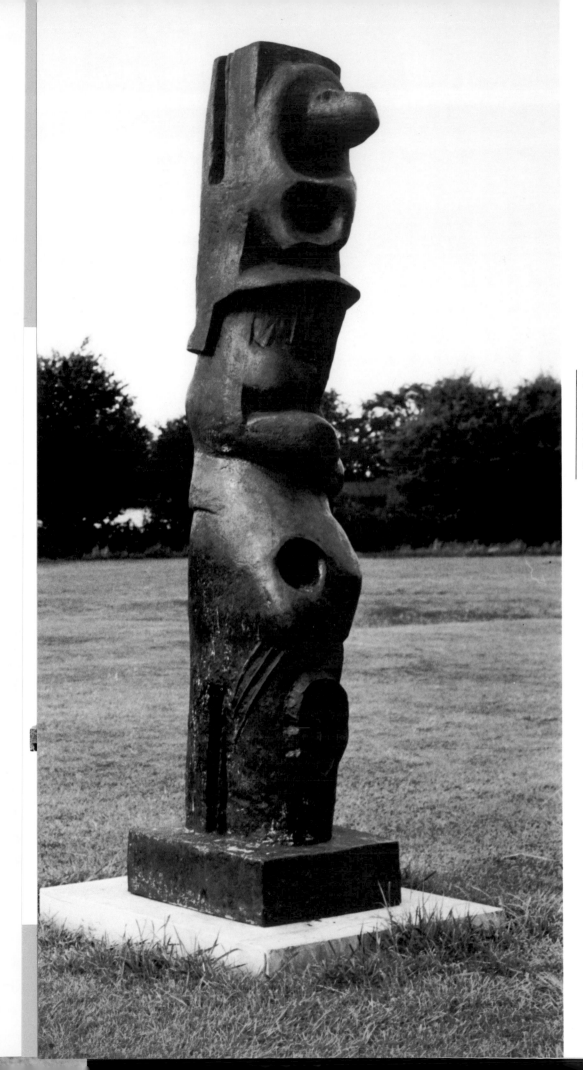

◁
Upright Motive, no. 5
1955-56
Bronze
H. 84½ in.
Weintraub Gallery, New York,
and Albert White Gallery, Toronto

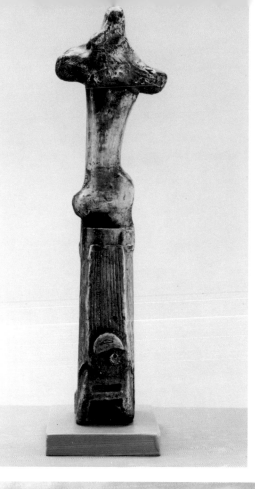

▷
Upright Motive, no. 1 (maquette)
1955 Original plaster H. 12⅛ in.
Art Gallery of Ontario, Toronto,
Gift of the artist

▽
Upright Motive, no. 1: Glenkiln Cross. 1955–56. Bronze H. 132 in.
The first cast of the Cross as installed at Glenkiln Farm
Estate, Dumfries, Scotland. Subsequent castings are in the
collections of the Hirshhorn Museum and Sculpture
Garden, Washington, D.C., and the Amon Carter Museum,
Fort Worth, Texas.

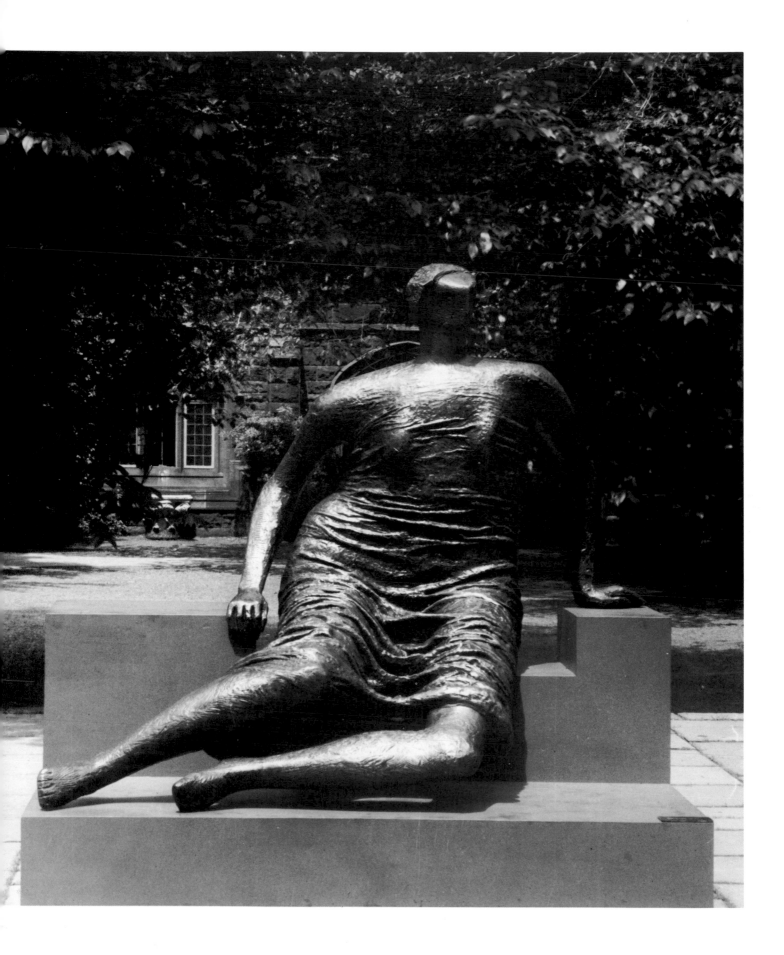

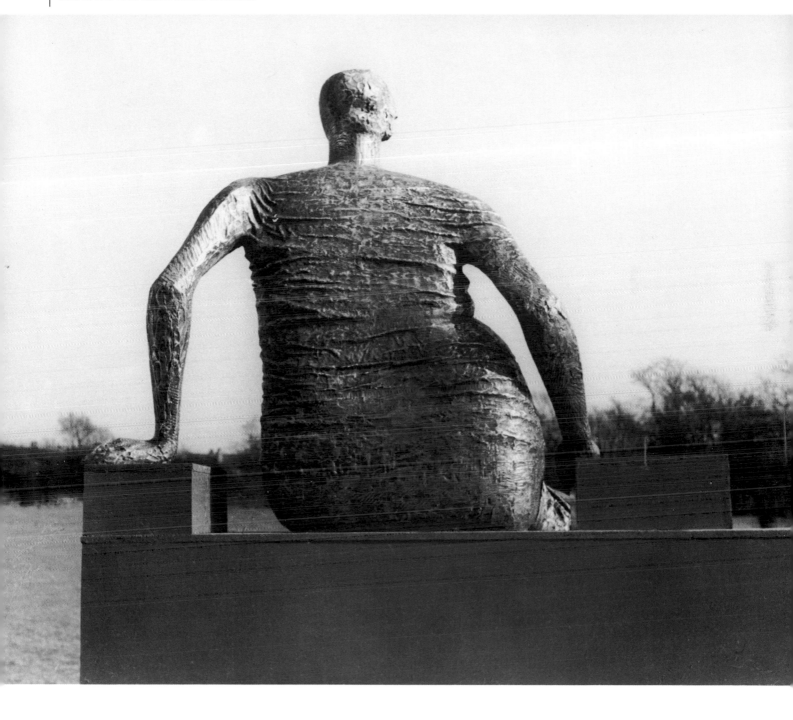

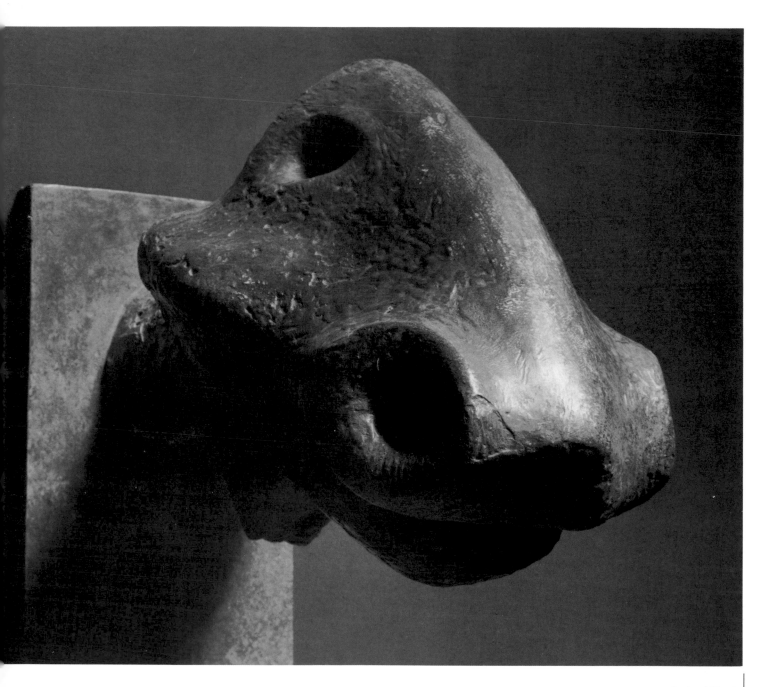

Animal Head
1956
Bronze
L. 22 in.
Tate Gallery, London,
Gift of the artist

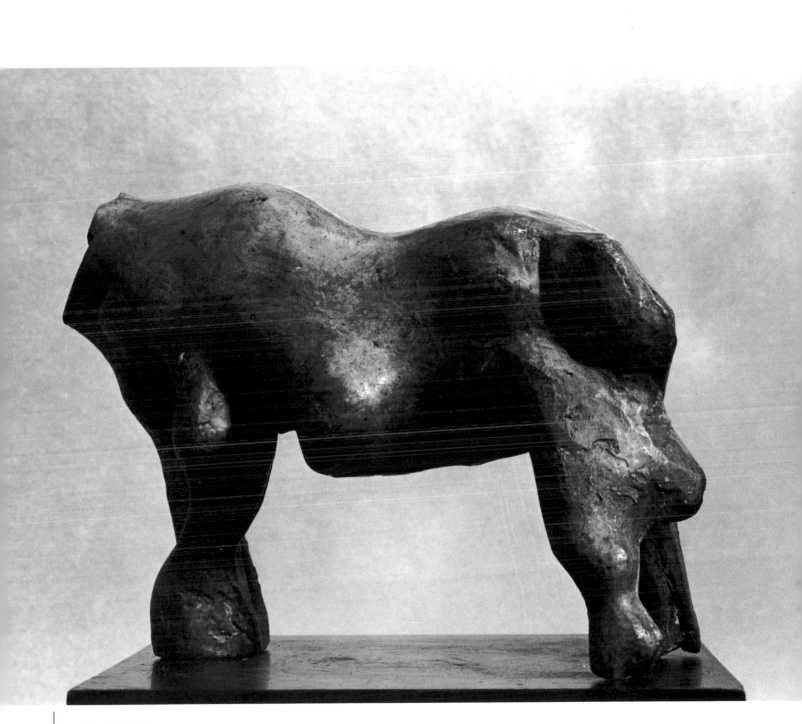

Headless Animal
1960
Original plaster
L. 9½ in.
The Henry Moore
Foundation

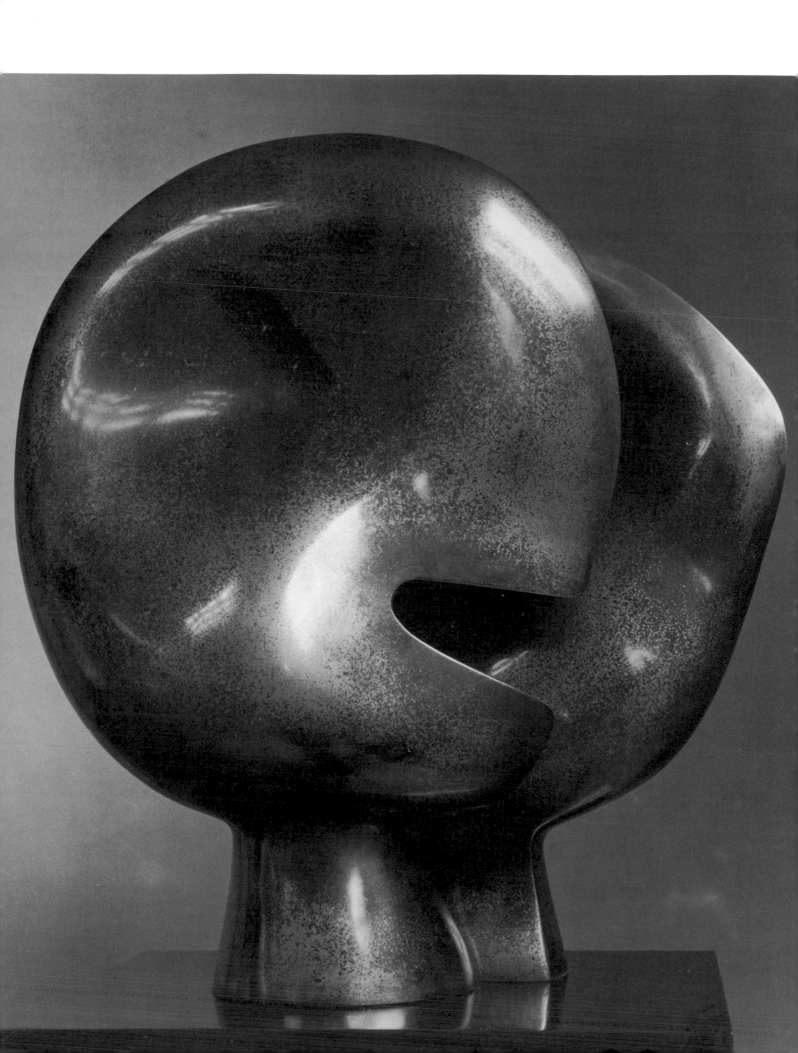

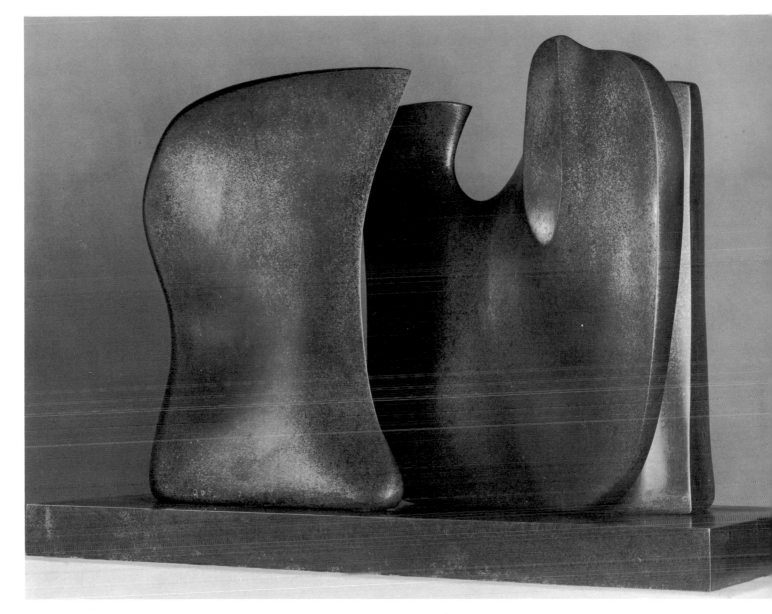

Above and right:
Knife-Edge Two-Piece (working model) 1962 Bronze L. 28 in.
Tate Gallery, London, Purchase

◁
Moon Head 1964 Bronze H. 22½ in. Tate Gallery, London, Gift of the artist

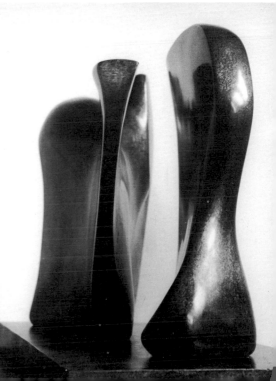

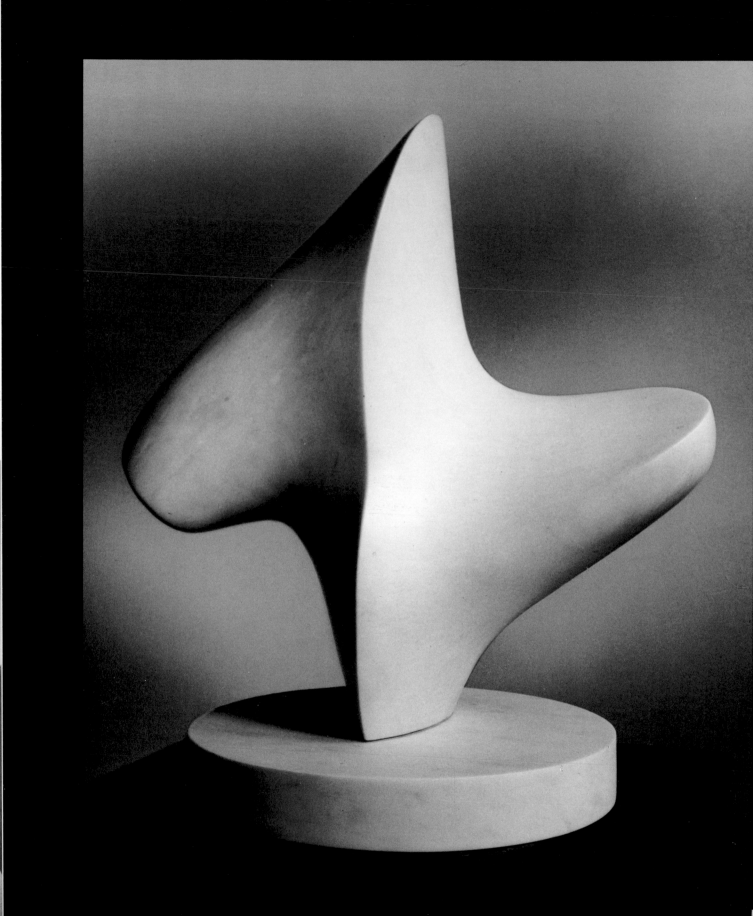

Upright Form: Knife-Edge 1966 Rosa Aurora marble H. 23½ in.
Tate Gallery, London, Presented by the artist in memory of Sir Herbert Read

Torso 1966 White marble H. 31 in.
The Staehelin Collection, Feldmeilen, Switzerland

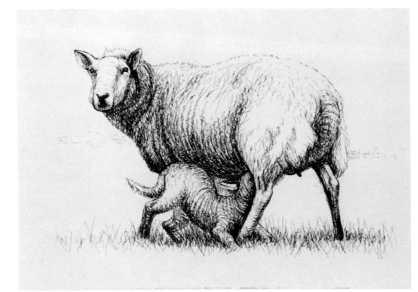
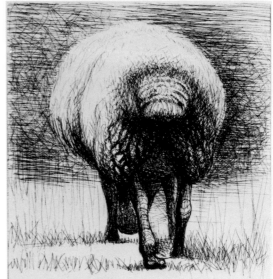

Sheep Album: Sheep with Lamb, I
1972
Etching with drypoint
5⅞ x 8⅛ in.
The Henry Moore Foundation

<div align="right">

Sheep Album: Sheep Back View
1972
Etching
8⅜ x 7⅜ in.
The Henry Moore Foundation

</div>

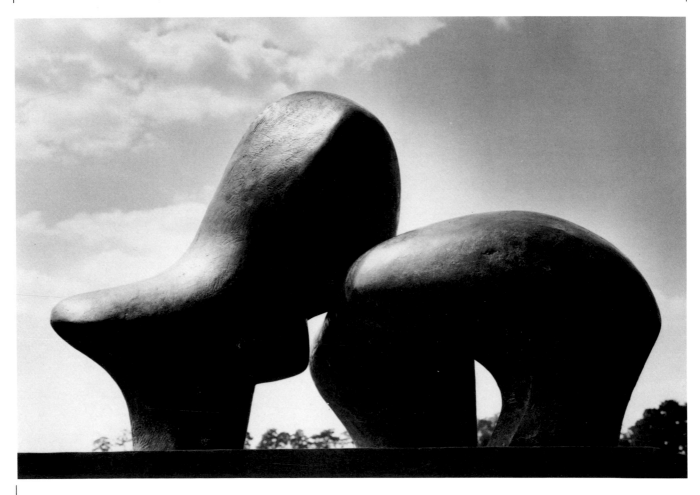

Sheep Piece (working model) 1971 Bronze L. 56 in. Grace and Joseph Penner, Sarasota, Fla.

Recent Sculpture

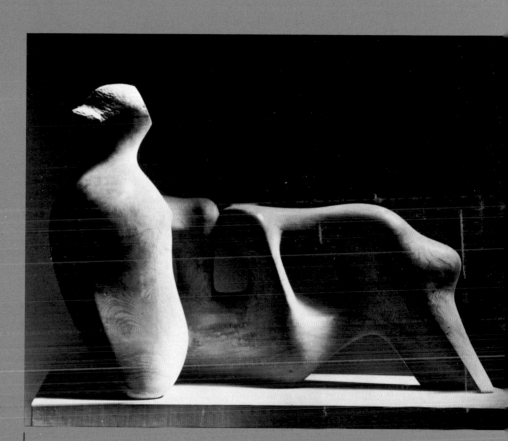

Reclining Figure: Holes
1975-78
Elm wood
L. 87½ in.
The Henry Moore Foundation

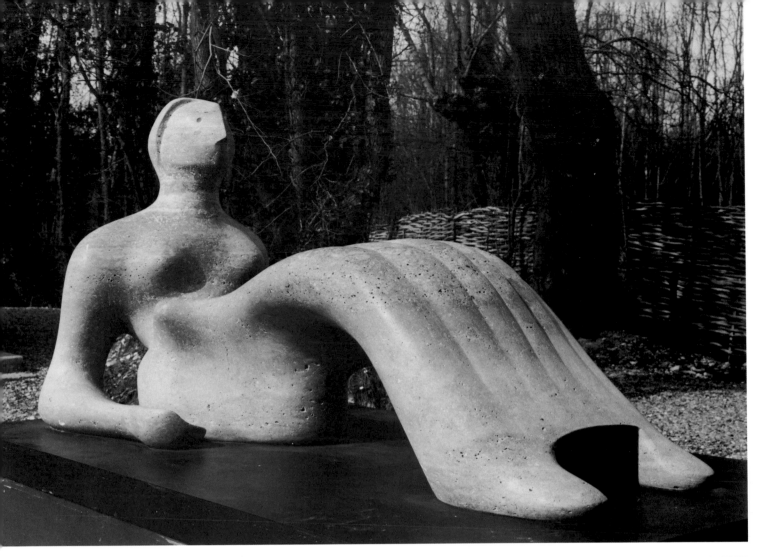

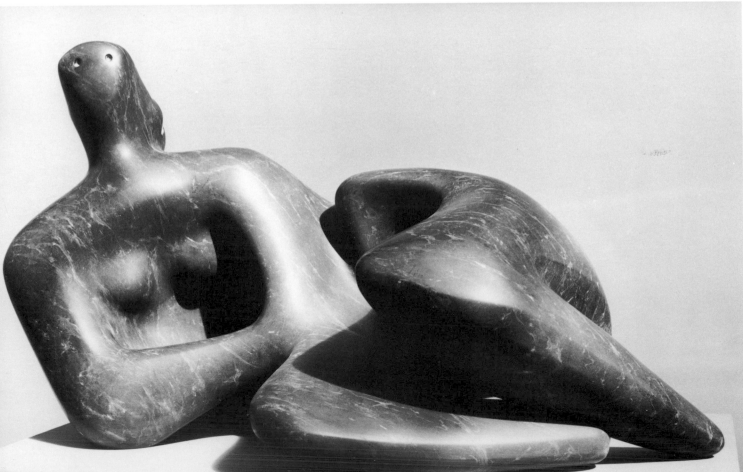

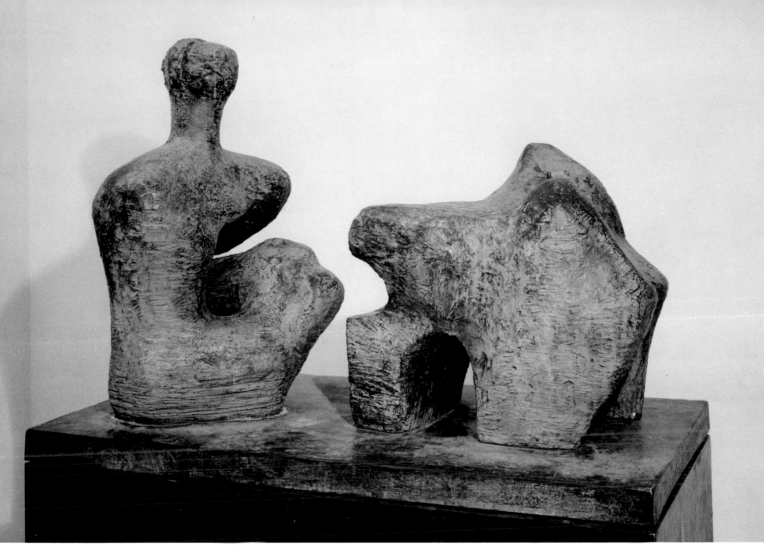

Top:
Two-Piece Reclining Figure, no. 4
1961
Bronze
L. 43 in.
Albright-Knox Art Gallery, Buffalo, N.Y.,
Gift of the Seymour H. Knox
Foundation, Inc.

Right:
Reclining Figure: Arch Leg (maquette)
1969
Bronze
L. 7¼ in.
Laura and David Finn, New York

Top left:
Reclining Figure: Bone Skirt
1978
Roman travertine marble
L. 68⅞ in.
The Henry Moore Foundation

Left:
Reclining Figure: Curved
1977
Black marble
L. 56½ in.
The Jeffrey H. Loria Collection, New York

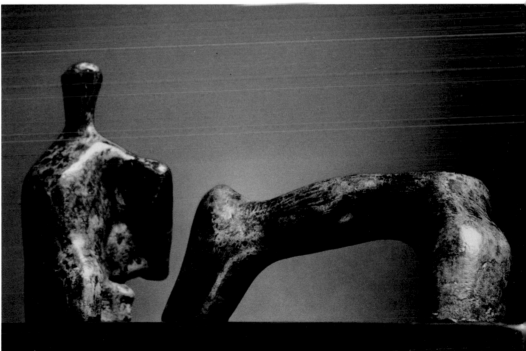

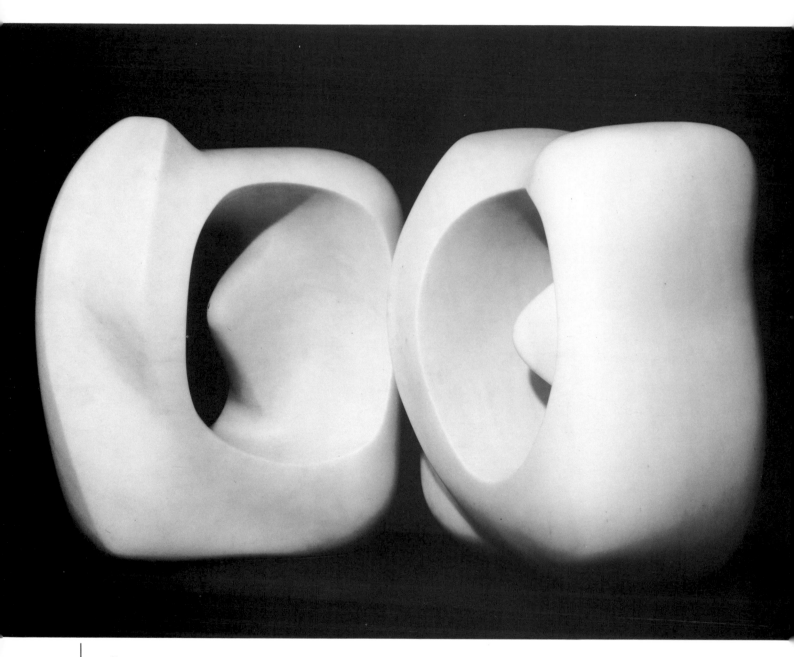

Double Tongue Form
1972
Carrara marble
L. 30 in.
Marlborough Gallery, New York

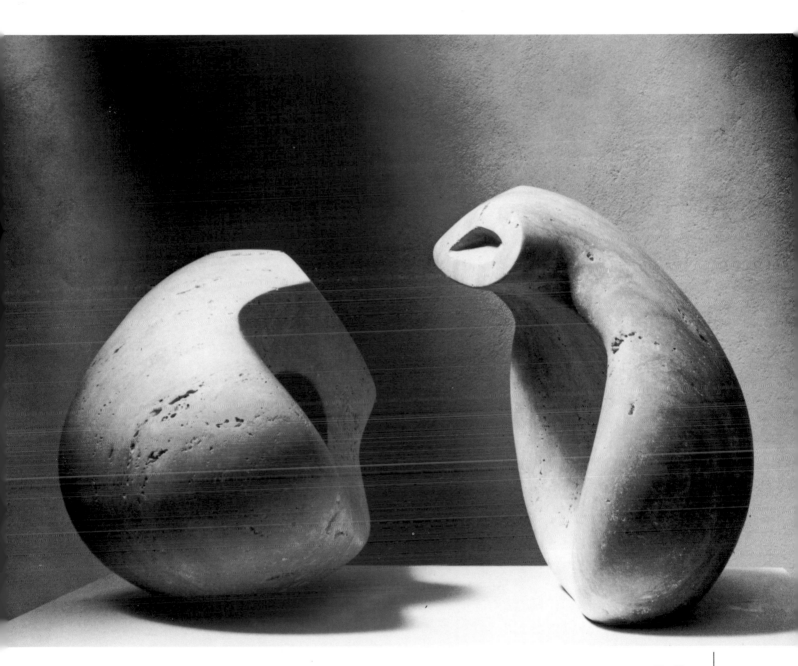

Two Forms
1975
Roman travertine marble
L. 34½ in.
Fischer Fine Art Ltd., London

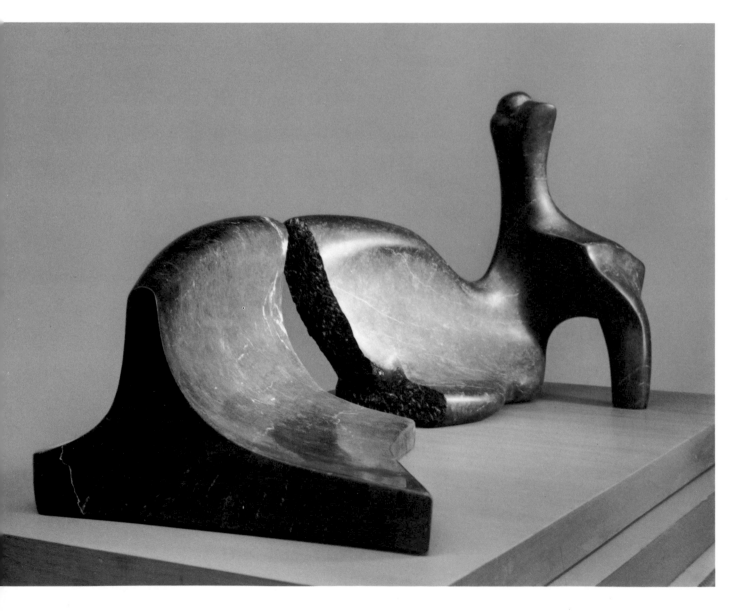

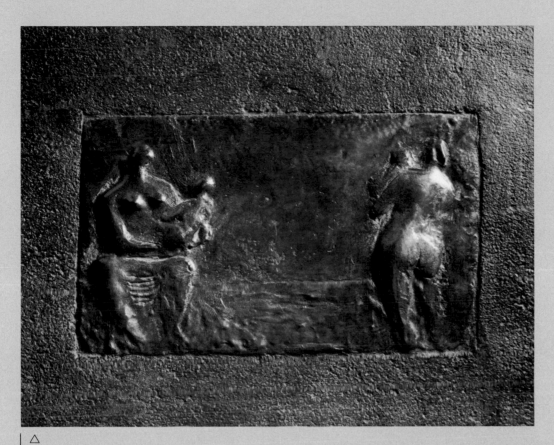

△
Mothers with Children 1977 Bronze H. 18¾ in.
Paul and Pauline Goodman, Baltimore

▽
Three Bathers After Cézanne 1978 Bronze l. 12 in.
Private Collection

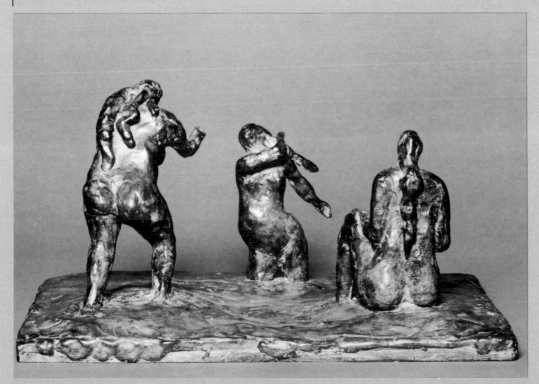

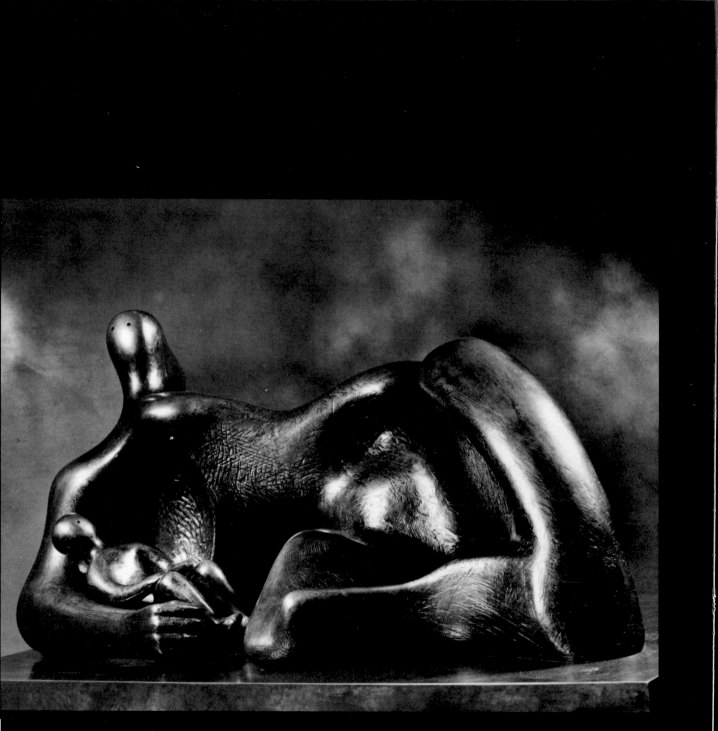

Draped Reclining Mother and Child
1982
Bronze
L. 31 in.
The Jeffrey H. Loria Collection, New York

Checklist

Works marked with an asterisk (*) are illustrated in this book.

Sculpture

Head of a Girl
1922
Wood
H. 9½ in. (24.1 cm)
City Art Gallery, Manchester, England
LH, I, 4

Standing Woman
1923
Walnut wood
H. 12 in. (30.5 cm)
City Art Gallery, Manchester, England
LH, I, 5

*Figure
1923
Verde di prato
H. 15½ in. (39.4 cm)
Private Collection
LH, I, 8

Standing Nude
1924
Portland stone
H. 22 in. (55.9 cm)
Private Collection
LH, I, 16

*Seated Figure
1924
Hopton-wood stone
H. 10 in. (25.4 cm)
The Henry Moore Foundation, Much Hadham, England
LH, I, 19

*Woman with Raised Arms
1924–25
Hopton-wood stone
H. 17 in. (43.2 cm)
The Henry Moore Foundation, Much Hadham, England
LH, I, 23

*Mother and Child
1924–25
Hornton stone
H. 22½ in. (57.2 cm)
City Art Gallery, Manchester, England
LH, I, 26

*Torso
1926
Cast concrete
H. 8½ in. (21.6 cm)
Mrs. Allan D. Emil, New York
LH, I, 37

Bird
1927
Bronze
L. 9 in. (22.9 cm)
The University of Michigan Museum of Art,
Ann Arbor, Gift of Mr. and Mrs. Marvin E. Klein
LH, I, 39

*Serpent's Head
1927
Stone
H. 8 in. (20.3 cm)
Private Collection
LH, I, 45

*Torso
1927
African wood
H. 15 in. (38.1 cm)
Mr. and Mrs. John L. Loeb, New York
LH, I, 47

*Mask
1929
Stone
H. 5 in. (12.7 cm)
Private Collection
LH, I, 61

*Seated Figure
1929
Cast concrete
H. 17¾ in. (45.1 cm)
The Henry Moore Foundation, Much Hadham, England
LH, I, 65

*Half-figure
1929
Hornton stone
H. 10 in. (25.4 cm)
Mrs. Allan D. Emil, New York
LH, I, 68

Reclining Figure
1929
Alabaster
L. 18¾ in. (47.6 cm)
Soprintendenza Per I Beni Artistici E Storici, Milan
LH, I, 71

Figure
1930
Ebony
H. 10 in. (25.4 cm)
Private Collection
LH, I, 80

*Mother and Child
1930
Ancaster stone
H. 10 in. (25.4 cm)
Private Collection
LH, I, 82

*Mother and Child
1930
Ham Hill stone
H. 31 in. (78.7 cm)
Private Collection
LH, I, 83

Mother and Suckling Child
1930
Alabaster
H. 12 in. (30.5 cm)
Soprintendenza Per I Beni Artistici E Storici, Milan

Head
1930
Slate
H. 10 in. (25.4 cm)
Soprintendenza Per I Beni Artistici E Storici, Milan
LH, I, 89

*Seated Figure
1930
Alabaster
H. 18¼ in. (46.4 cm)
Art Gallery of Ontario, Toronto
Purchase, 1976
LH, I, 92

*Reclining Figure
1930
Ancaster Stone
L. 21 in. (53.3 cm)
The Detroit Institute of Arts, Founders Society
Purchase, Friends of Modern Art Fund
LH, I, 94

*Mother and Child
1931
Sycamore wood
H. 30 in. (76.2 cm)
Soprintendenza Per I Beni Artistici E Storici, Milan
LH, I, 106

Half-figure
1931
Alabaster
H. 12¼ in. (31.1 cm)
Private Collection
LH, I, 108

*Girl
1931
Ancaster stone
H. 29 in. (73.7 cm)
Tate Gallery, London
Purchase, 1952
LH, I, 109

*Figure
1931
Beech wood
H. 9¾ in. (24.8 cm)
Tate Gallery, London
Bequest of E. C. Gregory, 1959
LH, I, 111

*Girl
1932
Boxwood
H. 12½ in. (31.8 cm)
Private Collection
LH, I, 112

*Half-figure
1932
Armenian marble
H. 27 in. (68.6 cm)
Tate Gallery, London
Bequest of E. C. Gregory, 1959
LH, I, 117

Head
1932
Carved concrete
H. 17½ in. (44.5 cm)
Soprintendenza Per I Artistici E Storici, Milan
LH, I, 123

*Figure
1932
Lignum vitae wood
H. 10 in. (25.4 cm)
The University of Michigan Museum of Art,
Ann Arbor
LH, I, 127

*Composition
1933
Walnut wood
H. 12 in. (30.5 cm)
Private Collection
LH, I, 132

*Composition
1934
Bronze (cast 1961)
L. 20½ in. (52.1 cm)
Arts Council of Great Britain
Purchase, 1963
LH, I, 140

Carving
1934
African wonderstone
H. 4 in. (10.2 cm)
The Henry Moore Foundation, Much Hadham, England
LH, I, 142

*Two Forms
1934
Ironstone
H. 7¼ in. (18.4 cm)
Private Collection
LH, I, 146

Two Forms
1934
Bronze (cast 1967)
H. 8 in. (20.3 cm)
The Metropolitan Museum of Art, New York
Gift of Harry A. Brooks to honor Henry Moore
on his 85th Birthday, 1982
LH, I, 146

Glenkiln Cross, Plate II
1972
Etching, drypoint, and aquatint
Plate size: 8½ x 6¼ in. (21.6 x 15.9 cm)
Cramer, I, 188

*Stonehenge Album
1972, 1973
1 etching and 15 lithographs
Each sheet: 17⅛ x 23 in. (45.4 x 58.4 cm)
Cramer, II, 202–203 and 207–223

*Sheep Album
1972, 1974
17 etchings
Each sheet: 12 x 15¼ in. (30.5 x 38.7 cm)
Cramer, I, 196–201, and Cramer, II, 225–235

Girl Doing Homework, V
1974
Etching and aquatint
Plate size: 5 x 5½ in. (12.7 x 14 cm)
Cramer, II, 330

Trees Album 1979
6 etchings
Each sheet: 21¼ x 17½ in. (54 x 44.5 cm)
Cramer, III, 547–552

*The Artist's Hand Portfolio 1979
2 etchings and 3 lithographs
Plate sizes vary: Plates I, III, V: 20 x 15 in.
(50.8 x 38.1 cm); Plate II: 14¾ x 19¾ in.
(37.5 x 50.2 cm); Plate IV: 20 x 14¾ in.
(50.8 x 37.5 cm) Cramer, III, 553–557

Bibliography

The bibliography of writings on Henry Moore is voluminous. Thus far, four volumes of the catalogue raisonné of his sculpture have been published by Lund, Humphries. The most informative text on his life and art is John Russell's invaluable monograph published in 1968 and revised in 1973. Catalogues accompanying four recent exhibitions contribute considerable additional information. Two of these are by Alan G. Wilkinson, curator of the Henry Moore Sculpture Centre at the Art Gallery of Ontario. The other two exhibition catalogues are British Sculpture in the Twentieth Century and Henry Moore: Early Carvings 1920–1940. Further information about these publications is included in the brief bibliography that follows.

Clark, Kenneth. Henry Moore Drawings. New York: Harper & Row, Publishers, 1974.

Finn, David. Henry Moore: Sculpture and Environment. New York: Harry N. Abrams, Inc., 1976.

Garrould, Ann, Terry Friedman, and David Mitchinson. Henry Moore: Early Carvings 1920–1940. Exhibition catalogue. Leeds, U.K.: Leeds City Art Galleries, 1982.

Grohmann, Will. The Art of Henry Moore. London: Thames and Hudson Ltd., 1960.

Hedgecoe, John, and Henry Moore. Henry Moore. London: Thomas Nelson and Sons Ltd., 1968.

Henry Moore: Catalogue of Graphic Work. Vol. 1: 1931–1972, edited by Gérald Cramer, Alistair Grant, and David Mitchinson. Geneva: Gérald Cramer, 1973. Vol. 2: 1973–1975, edited by Gérald Cramer, Alistair Grant, and David Mitchinson. Geneva: Gérald Cramer, 1976. Vol. 3: 1976–1979, edited by Patrick Cramer, Alistair Grant, and David Mitchinson. Geneva: Patrick Cramer, 1980.

Henry Moore on Sculpture. Edited by Philip James. London: Macdonald & Co., Ltd., 1966.

Henry Moore: Sculpture and Drawings. Vol. 1: Sculpture and Drawings 1921–48, edited by David Sylvester; Vol. 2: Sculpture and Drawings 1949–54, introduction by Herbert Read; Vol. 3: Complete Sculpture 1955–64, edited by Alan Bowness; Vol. 4: Complete Sculpture 1964–73, edited by Alan Bowness; Vol. 5: Complete Sculpture 1974–80, edited by Alan Bowness. London: Percy Lund, Humphries and Co., Ltd., vol. 1, 2d ed., 1957; vol. 2, 2d ed., 1965; vol. 3, 1965; vol. 4, 1977; vol. 5, 1983.

Levine, Gemma. With Henry Moore: The Artist at Work. London: Sidgwick & Jackson, 1978.

Melville, Robert. Henry Moore: Sculpture and Drawings 1921–1969. New York: Harry N. Abrams, Inc., 1970.

Mitchinson, David, ed. Henry Moore Sculpture with Comments by the Artist. Introduction by Franco Russoli. New York: Rizzoli International Publications, Inc., 1981 (Hardbound reprint of 1981 Madrid exhibition catalogue Henry Moore: Sculptures, Drawings, Graphics 1921–1981).

Moore, Henry. Henry Moore at the British Museum. London: British Museum Publications Ltd., 1981.

Nairne, Sandy, and Nicholas Serota, eds. British Sculpture in the Twentieth Century. Exhibition catalogue. London: Whitechapel Art Gallery, 1981.

Read, Herbert. Henry Moore: Sculptor. London: Zwemmer, 1934.

Read, John. Henry Moore: Portrait of an Artist. London: Whizzard Press, 1979.

Russell, John. Henry Moore. New York: G. P. Putnam's Sons, 1968; rev. ed., Pelican Books, 1973.

Sweeney, James Johnson. Henry Moore. New York: The Museum of Modern Art, 1946.

Sylvester, David. Henry Moore. Catalogue of Tate Gallery exhibition. The Arts Council of Great Britain, 1968.

Wilkinson, Alan G. The Drawings of Henry Moore. London: Tate Gallery and Art Gallery of Ontario, 1977.

————.The Moore Collection in the Art Gallery of Ontario. Toronto: Art Gallery of Ontario, 1979.

Photographs on the pages indicated appear courtesy of: Acquavella Galleries, Inc., New York (p. 73, top left); Albright-Knox Art Gallery, Buffalo, N.Y. (p. 41; p. 64, top; p. 113, top); Art Gallery of Ontario, Toronto (p. 25; p. 50, top; p. 52, top; p. 59; p. 85; p. 87, bottom; p. 118, top); The Art Institute of Chicago (p. 50, bottom; p. 82); Arts Council of Great Britain (p. 10); Prudence Cuming Associates Ltd., London (p. 18, right; p. 24; p. 70, bottom left; p. 115); The Detroit Institute of Arts (p. 27); David Finn (p. 84, bottom; p. 74; p. 98); Fischer Fine Arts Ltd., London (p. 105, bottom); Charles Gimpel (p. 86); Hirshhorn Museum and Sculpture Garden, Smithsonian Institution, Washington, D.C. (p. 35, top); Errol Jackson Photography, London (p. 23; p. 26; p. 44; p. 49; p. 96, top; p. 105, top); M. Knoedler and Company, Inc., New York (p. 70, top right); Paulus Leeser (p. 50, top; p. 51, bottom); Marlborough Fine Arts Ltd., London (p. 33, top; p. 34, top; p. 35, bottom; p. 61; p. 77; p. 100; p. 104, bottom; p. 114); Henry Moore, Much Hadham (p. 28, right; p. 37; p. 38; p. 39; p. 62, top; p. 65; p. 71; p. 93; p. 95, bottom; p. 97, bottom; p. 103, top; p. 103, bottom; p. 104, top; p. 110, bottom; p. 111, bottom; p. 118, bottom; The Henry Moore Foundation, Much Hadham (p. 6; p. 8;

p. 19; p. 20; p. 39; p. 42, bottom; p. 45; p. 46; p. 54, top; p. 54, bottom; p. 55; p. 60; p. 66, bottom; p. 91; p. 102, bottom; p. 116; p. 117, top); James Mortimer (p. 73, top right); The Museum of Modern Art, New York (p. 17; p. 40; p. 34, bottom; p. 67; p. 68; p. 69, bottom; p. 92); O.E. Nelson (p. 36); Philadelphia Museum of Art (p. 43); The Portland Art Association (p. 58); Simon Reid, Dumfries (p. 73, bottom left; p. 87); F. Catala Roca Fotografo, Barcelona (p. 84, top); The Saint Louis Art Museum (p. 42, top); Peter Suschitzky (p. 22, top); Tate Gallery, London (p. 28, left; p. 29; p. 30, top; p. 48; p. 52, bottom; p. 53; p. 55, top; p. 70, bottom right; p. 95, top); University of Michigan Museum of Art, Ann Arbor (p. 47, top; p. 30, bottom); Yale University Art Gallery, New Haven (p. 88; p. 89).
Lenders have supplied the photographs that appear on the following pages: 21 (left), 22 (bottom), 31, 32, 47 (bottom right), 56, 57, 62 (bottom right), 63, 64, 69 (top), 75, 76, 78 (top), 78 (bottom), 80 (top), 80 (bottom right), 81, 83, 87, 96, 97 (top), 99, 101, 112 (top), 112 (bottom), 113 (bottom), 119.
All other photography was done by the Photograph Studio at The Metropolitan Museum of Art.